Chinese Painting Style

DATE DUE

DEMCO 38-296

中國畫之風格

謝伯珂著

辛酉暮春吳約 傅申署

Chinese Painting Style

Media, Methods, and Principles of Form

Jerome Silbergeld

University of Washington Press

Seattle and London

Library of Congress Cataloging-in-Publication Data
Silbergeld, Jerome.
 Chinese painting style.
 Bibliography: p.
 Includes index.
 1. Painting, Chinese. 2. Painting—Technique. I.Title.
ND1040.S47 751.42'51 81-21837
ISBN 0-295-95921-5 (pbk.) AACR2

The paper used in this publication meets the minimum requirements
of American National Standard for Information Sciences—Perma-
nence of Paper for Printed Library Materials, ANSI Z39.48-1984. ∞

The first edition of this book was published with the assistance of a
grant from the National Endowment for the Humanities.

Contents

Illustrations

Chronology of Chinese Dynastic Periods

Shang	ca. 16th-ca. 11th centuries B.C.
Chou	ca. 11th century-221 B.C.
Ch'in	221-206 B.C.
Han	206 B.C.-A.D. 221
Three Kingdoms and Six Dynasties	A.D. 221-581
Sui	581-618
T'ang	618-906
Five Dynasties	906-960
Sung	960-1279
Northern Sung	960-1127
Southern Sung	1127-1279
Yüan	1279-1368
Ming	1368-1644
Ch'ing	1644-1911

Preface

This book was originally written for my own students. As I composed it, I naturally thought back many times to the teachers who shaped my education and whose influence may be found throughout these pages. Among them was one I never met, the late George Rowley of Princeton, whose *Principles of Chinese Painting* was the first work on Oriental art that I read and a work of lasting influence; while dated and in some ways problematical, Rowley's imaginative and challenging introduction to the style and aesthetics of Chinese painting was a major stimulus in this attempt to deal with the basic aspects of Chinese painting style. I am no less indebted in writing this book to three teachers who directed my study of Chinese painting, and whose encouragement and intellectual generosity I wish to acknowledge here: Professor Wen Fong of Princeton University; Professor Esther Jacobson-Leong of the University of Oregon; and Professor Michael Sullivan of Stanford University.

I would like to express my gratitude to those museums, private collectors, and other individuals who gave permission to illustrate or provided photographs for the works used in this book, including the Art Museum, Princeton University; the Field Museum of Natural History, Chicago; the Freer Gallery of Art, Washington, D.C.; the Metropolitan Museum of Art, New York; the Museum of Fine Arts, Boston; the National Palace Museum, Taipei; the Tokyo National Museum; Sen'oku Hakkokan, the Sumitomo Collection Tokyo; Professor James Cahill, University of California at Berkeley; Mr. John M. Crawford, Jr., New York; Mr. Mitsui Takanaru, Tokyo; Mr. Sasaki Johei, Agency of Cultural Affairs, Tokyo; Mr. C. C. Wang, New York; Mr. Wan-go H. C. Weng, Lyme, New Hampshire; and Mrs. Yoshikawa Fumiko, Tokyo. I am very grateful to Dr. Shen C. Y. Fu of the Freer Gallery for inscribing the calligraphic frontispiece of this book; to Karl Lo, Head, East Asia Library, University of Washington, for the intra-textual calligraphy; to Barbara Paxson for her assistance in illustrating figures 1 and 2; and to the staff of University of Washington Press, particularly Naomi Pascal, Julidta Tarver, Audrey Meyer, and Kitti Blank, for all of their professional skill and the cooperative spirit which they brought to this project. This book would not have come about without the spirited encouragement and careful scrutiny provided at every stage by my wife, Michelle DeKlyen.

The writing of this book was sponsored by grants from the Graduate School Research Fund, the School of Art, and the China Program (Chester A. Fritz Endowment) of the University of Washington. The publication has been supported by a generous grant from the National Endowment for the Humanities.

University of Washington
Seattle, 1982

Chinese Painting Style

Introduction

Painting is a language. Emerging from the partly conscious, partly unconscious interior of the artist, it reaches us through the somewhat controlled, somewhat chance manipulation of brush, pigments, and ground. The visually delivered message plays on our experience and imagination with all the power of a verbal language, arousing feelings and thoughts, memories and imagination, and releasing stores of mental energy. In our personal encounter with painting, there may be no need to translate this language into any other, no need to transform visual images into words. The visual image is a self-sufficient reality which verbal translation can do no better than very crudely approximate. But for those who wish to go beyond the entirely personal and purely visual experience of art, who want to enter into the study of artists, styles, and history, and who need to communicate this study with others, some skill in talking about what one sees is necessary and a stylistic vocabulary is essential. In fact, really *seeing* what one looks at becomes a challenge, and language becomes a valuable guide to the eye.

When writing, poets need not have their thoughts fixed on parts of speech and punctuation, yet they cannot do without them. When painting, artists need not have foremost in mind concepts like tone and texture, plasticity and perspective, yet they apply them all of the time, and have probably learned to look at the world with a heightened appreciation of nature's own colors, textures, and patterns. Both the skilled poet and the master painter apply their grammar intuitively, but only because they have mastered it through repeated study and practice. Chinese art history records very few precocious painters; just as few were born knowing instinctively how to view and talk about painting. Even after years of viewing and appreciation, viewers may not recognize whole aspects of the art if they are not alert to the many factors of execution and style brought into play by the artist.

The art of painting is visual, not verbal, and our primary grasp of it should be visual. Yet the verbal analysis of a painting need not reduce artistic subtlety and expression to a lifeless system of intellectual concepts. Knowing what to look for in a work can only enhance the appreciation of all the elements at play in a fine painting and of what makes it so fine. The famous early Chinese philosopher, Chuang-tzu, wrote: "The trap exists because of the fish; once you've gotten the fish, you can forget the trap. . . . Words exist because of the meaning; once you've gotten the meaning, you can forget the words."[1] These few chapters are but a small trap for capturing something so vast and elusive as Chinese painting style, but I hope they will offer the viewers of this art some means of attaining an enriched visual experience.

The organization of these chapters progresses from the simple to the complex, from the material means of expression to the subtlety of expression itself. Also, this work is not primarily historical in its concern, and the works illustrated are not intended as a balanced sample of all periods or stylistic movements; nevertheless, most of these examples were selected for their availability in works on the history of Chinese art, and it is hoped that this book will help readers to better understand the stylistic basis of art historical development. Finally, a book about style should give some definition of the

term. However, avoiding a discussion of all the varied meanings and subtle connotations which the term "style" has come to possess, I will simply define visual style as "the way things look."[2] One major emphasis of the chapters which follow is that beauty, stylistic expression, naturalism, and "the way things look" all have a formal basis which is surprisingly apparent both to the trained eye and to the common sense of the viewer.

The stylistic terms and concepts used in this short work are not set forth as a rigid or absolute system of stylistic analysis, for Chinese painters operated by no such system. But they suggest ways of perceiving the artists' means and of gauging what they have accomplished. I hope that readers will put these suggestions to good use, refine and expand upon them, correct them where necessary, and through them gain a measure of independence in their study and enjoyment of Chinese painting.

Materials and Format

Apainting, of course, is more than the sum of its physical parts. Yet even so subtly aesthetic and profoundly philosophical an art as Chinese painting must have some material point of departure. Refinement must be preceded by basics; as an ancient poem quoted by Confucius said, "The laying on of colors follows the preparation of the plain ground."[1] Chinese artists and connoisseurs have left a considerable literature on the "four treasures" of the painter—brushes, ink, inkstone, and paper—and these will be among the materials considered here.

Brush

Among the equipment most treasured by Chinese artists were their brushes, simple in appearance but subtle in design, extraordinarily flexible and most difficult to use. The Chinese brush consisted of a bundle of animal hairs stuffed into a bamboo tube. The bundle was not uniform but composed of three major sections (fig. 2a). Innermost was a long core, sometimes waxed to stiffen it. Surrounding this core, layers of shorter hair formed a mantle, thickening the bundle at the base and the middle, but not reaching to the tip of the core. One or more outer layers, tied around these sections, reached fully from base to tip, swelling around the mantle and curving back gradually to meet the tip of the core, thus creating an empty space where the mantle slackened off. This space acted as a reservoir where water-based ink or pigments naturally accumulated. The supply of fluid pigments allowed the artist to complete an extended linear movement or several shorter movements before having to dip the brush once again.

Individual brushes came in a great variety of sizes and shapes, and each left its own characteristic trace. A long, tapering, pointed bundle was ideal for swirling movements and for lines that ranged in width from points to swells (figs. 8, 27). A short and stumpy brush left a blunt impression, and some artists preferred a worn-out brush for its simple, understated effect (fig. 30). Whether a brush was stiff or soft depended in part on the type of hair used (wolf hair, for example, being quite springy compared to goat, and rabbit hair firmer still), and in part on whether the core had been treated with wax. A stiff and springy waxed-core brush contributed to the dynamic thickening and thinning of line (fig. 25), while a softer unwaxed brush produced a more even line, as in architectural renderings (fig. 23a). A thick, soft-haired brush was used to apply a broad, smoothly graded wash of ink or color (pl. 4, fig. 22a-d).

Ink and Pigments

Next to consider among the artists' materials are their pigments. Black ink, the staple of many Chinese artists, was historically regarded quite differently than colored pig-

ments. Chinese inks were obtained from pine resins or tung oil, burned beneath a hood to produce a residue known as lampblack. This lampblack was collected, mixed into a solution with glue, pressed into molds, and dried. The result was an ink cake or ink-stick, which had to be ground back into a watery solution immediately before painting, for ink sours after only a few hours time. The time spent grinding the ink was often one of mental preparation and intense concentration of the artist's creative energy. The ink cakes, more than simply being utilitarian, were often molded in decorative shapes or with elaborate pictorial designs.

Colored pigments, like ink, came in dried cake and stick forms. They were derived from a wide variety of vegetable and mineral sources. The most important of these pigments were blue, derived from indigo or mineral azurite, green from various vegetable substances and from malachite, lead white, and red produced from cinnabar and iron oxide. Chinese artists used these pigments in their natural hue rather then adjusting them to spectrally true reds or blues. Artists were free to produce yet other colors by mixing two or more pigments, but before the eighteenth century they rarely did this, and traditional Chinese paintings seldom display a spectrum of closely related colors (pls. 1-6). Still, the pigments themselves sometimes supplied the artist with a range of related hues, as did malachite green, which in watery solution naturally separates into three horizontal layers, ranging from a pale green above to a rich blue-green below. The three different colors juxtaposed in plate 4 (cf. fig. 22b-d) are the result of this phenomenon. Cinnabar (fig. 22e, f) and azurite, in solution, similarly settle into a range of related colors.

Black ink and colored pigments were all used with a water base, which allowed them to flow freely from the brush and made possible the extended brush movements and fluid linearity so pronounced in Chinese painting. A valuable part of the Chinese artist's equipment, perhaps the most dearly treasured, was the inkstone on which the cakes were ground into solution. It included a depressed reservoir for holding water and a raised flat area for grinding. Inkstones appeared in a wide variety of forms, ranging from a simple rectangle (fig. 38) to the ornate and sculpturesque.[2] A little pigment ground into water produced a transparent solution; with more pigment, the solution became more opaque. Generally, mineral pigments produced a richer, more opaque solution than ones derived from vegetable sources. Artists were especially skilled at adjusting the richness of their solutions, sometimes on the inkstone where they obtained a broad range of grays (figs. 27, 30), sometimes directly on the painting itself by first applying color and then fading it out with a wet, uncolored brush (pl. 4, fig. 22a). Often, artists prepared a very pale ink solution for a preliminary underdrawing, then subsequently disguised it by a more opaque solution laid on with seemingly more spontaneous brushwork. Frequently working in a transparent to semi-opaque range of solutions, artists tended to compose nearby objects first, background objects later.

An important factor in ink and pigments was their glue base. Incorporated into the cakes, this glue permanently fixed the pigments once they had dried. The technique of adding water to pigments directly on the silk (pl. 4, fig. 22a), just mentioned, had to be accomplished quickly or not at all, for a second layer added to an already-dry first layer in no way disturbed the first or caused it to bleed (fig. 27b). The belated development in the eighth century of layered painting techniques took advantage of this phenomenon and revolutionized Chinese painting style, introducing graded color and ink washes as a means of building up rounded, naturalistic forms (cf. figs. 27, 29). On the other hand, the strong glue fixative meant that a mistake, once made, was difficult to remedy. The

story of Ts'ao Pu-hsing, painting on command for a tyrannical ruler in the third century A.D., illustrates this fact. In the midst of his performance, he lost control of his brush and a stray drop of ink landed on the silk, impossible to hide and spoiling his design. Unable to remove it, Ts'ao quickly added a few strokes, turning the smudge into a fly so realistic that his patron tried to whisk it away. Lacking such ingenuity, most artists therefore prepared themselves before painting with extreme mental concentration.

Ground

Most studies of the various physical aspects of Chinese painting have paid little attention to the ground (base or surface) on which the ink and pigments were laid. For the past thousand years, the vast majority of Chinese paintings were set down on silk and paper; today, these two media constitute the bulk of surviving works of all periods. In earlier centuries, however, wall painting was part of the great tradition of Chinese painting (fig. 16); and lacquer painting, although regarded as a minor art or craft, attained great stylistic heights (fig. 36). Earlier still, during China's prehistoric period, a tradition of painted ceramics evolved that was unsurpassed in the world's other neolithic cultures (fig. 35).

Clay wall. Little is known about Chinese wall painting before the early Han period. But the earliest known traces of wall painting, while fragmentary, suggest that by the late Shang period walls and pillars were painted with the same stylized figures that everywhere adorned the ceremonial bronzes (fig. 9), carved wood, stone, jade, and bone of that age, and were set in red and black pigments upon clay walls prepared with a white lime finish.[3] Although the development of wall painting during the next thousand years remains obscure, by the late Chou–early Han period, the clay wall had become a prominent format for paintings presented in a public manner. To the painting of walls, in palaces and homes, temples and tombs, were drawn countless artisans, usually joined in a group effort.

Wall painting has taken several forms, ranging from small bricks painted individually and later assembled, to large walls first prepared with smooth plaster surface and then painted. The latter form became most common and was surely the most imposing, its unified surface inviting a grand display of design and color (fig. 16).[4] The basic construction method used in recently discovered royal tombs of the T'ang period, dated A.D. 706, was first to cover the brick walls with a thick layer of gritty clay that was well mixed with straw and vegetable fiber. Over this was applied a thinner layer of fine clay, which was rubbed to a smooth finish. Finally, the wall was covered with a thin layer of white paint mixed with a sealing adhesive. The painting surface was a dry clay, and there was none of the race with time that affected artists working in the European fresco tradition. Wall painting usually called for considerable planning, giving rise to numerous reduced-scale sketches painted on hemp or paper, which were subject to final approval or rejection. Final, full-scale designs were also produced on hemp or paper and then transferred to the wall by several related means, such as the pounce technique. In this method, powdered chalk was tamped through needle-sized perforations made along the major outlines of the design. Afterwards, the physical markings left on the wall were connected with pale brushlines, forming an underdrawing that was later dis-

guised by darker, firmer lines. At the Horyu-ji Buddhist temple in Japan, walls painted in the early eighth century bear traces of knife marks that cut directly through a preliminary drawing, a technique probably used in China as well.

The routinized, group production of wall paintings left little room for an individual artist to rise above the ranks of his fellow workmen, and few professional painters established a personal reputation or had their name passed down to posterity. Wu Tao-tzu of the eighth century, who followed only his immediate mental conception, was a rare exception. In a rapid manner, he laid out a bold design in black ink, using neither compass nor straightedge, and then retired from the scene, allowing his colorists to complete the work. Such masters drew crowds of onlookers, but none of their works have survived or been rediscovered by archaeologists. While one might expect this art form to have remained forever popular, the near-demise of the Buddhist church as a patron of the arts in the ninth century A.D., the rise of the hanging scroll format at about the same time, and the development of amateur painting from the tenth century onward all contributed to the considerably reduced stature of wall painting since the Sung Dynasty.

Silk. Silk is produced from the cocoon of the silkworm, a practice invented by China's first farmers in the neolithic period, as early as 5000 B.C. Until the first millenium A.D., silk production was practiced exclusively by the Chinese. The entire process involves raising silkworms domestically, feeding them mulberry leaves cultivated specifically for that purpose and adhering precisely to their delicate annual life cycle, then boiling down and unravelling the silken strands of their cocoons (each strand about a mile long), reeling these strands into thread, and weaving the threads into fabric.

The primary use of silk was for clothing. Not until the later Chou period are there indications of the first use of silk as a medium for writing, which had until then been practiced on thin vertical slips of bamboo tied together and rolled up for storage (fig. 37). Silk proved a much more flexible and compact medium, and by the end of the Han Dynasty silk handscrolls, together with paper scrolls, had replaced bamboo as the standard medium of the writer. The use of silk in painting is first known to us from the third and second centuries B.C., several of the earliest examples being banners that were carried in funeral processions. It was in the handscroll format (figs. 12, 15, 17) that silk was most popularly used in painting during the first millennium A.D., and in the late T'ang and Sung periods, with the rise of hanging scrolls as a lightweight and flexible alternative to wall paintings (figs. 21, 22), silk became the pre-eminent medium for painting.

Ink or pigments applied to raw silk soak into the fabric, diluting the strength of color and the firmness of line. Traditionally, to combat this problem, Chinese silks were prepared for painting with an alum sizing brushed over the upper surface, producing a slick and not particularly absorbent ground. Strong colors and ink tones could then be built up in several carefully applied layers (pls. 2, 4, figs. 21, 27). Because a dry or rapidly moving brush may have trouble leaving a clear track on such a surface, the process of painting on silk was usually carried out in a slow and cautious manner. These factors contributed to the formality of paintings done on silk. The golden-tan hue of well-aged silk (pls. 4, 5), in contrast to the fresh, white color of paper (pls. 3, 6), added an air of dark solemnity to the paintings. Artists indulging in informal "ink play," or seeking the unusual effects of spontaneous brushwork, generally turned from silk to paper for its greater absorbency, as well as for its lesser expense (figs. 29, 32). In

the Yüan period, with the ascendance of amateur painting in China and the preference for casual sketching in place of formal painting, paper finally surpassed silk in significance (figs. 30-32). However, even throughout the later dynasties, silk remained the choice over paper for the "significant," formal painting.

Paper. The traditional Chinese date for the invention of paper is A.D. 105 and its inventor was said to be Ts'ai Lun. Though modern archaeology has shown paper made from hemp existed by the first century B.C., Ts'ai might well have helped bring the development of paper-making techniques to completion.[5] In later times, paper was made from various materials, including hemp, mulberry bark, and bamboo. Undoubtedly developed as an inexpensive medium for writing, paper quickly took a place beside silk for use in less important government documents and in personal letters. When calligraphy first attained the status of an amateur art form, in the third to fourth centuries A.D. (figs. 5, 7), paper was frequently preferred to silk, which retained more functional and formal connotations. Later, in the T'ang Dynasty, when the Chinese developed woodblock printing as an inexpensive means of mass producing and widely distributing literature, paper became the medium of printing, and its first association with pictorial designs perhaps came at that time, in the context of printed Buddhist scriptures. But not until the eleventh century was paper first consciously championed as a medium for painting promoted by the Chinese gentry. The gentry were distinguished by their literacy and scholarly education, a hard-earned achievement in traditional times but essential to any social, political, or cultural distinction. Painting as leisured amateurs and looking down on professional artists as uneducated craftsmen, this scholar-elite began to develop a distinctive mode of the art and turned from silk, used by the professional artists, to paper which they associated with the practice of calligraphy. With the ascendance of this scholar-amateur mode of painting in the fourteenth century (figs. 30-34), paper became, and has since remained, the pre-eminent ground for the Chinese painter.

Chinese paper, because of its unusually long fiber, will not disintegrate in water, even if repeatedly washed over with water-based pigments. Much more absorbent than silk, raw paper will virtually suck the ink from the brush, producing a blurred and blotted effect that is most difficult to manage. In order to give the writer or painter greater control over the flow of ink, manufacturers usually sized their paper with a dilute glue solution or with alum, producing a smoother, slightly water-resistant surface (figs. 8, 26). Only the most daring artists cared for the challenge of unsized or lightly sized paper (fig. 34). Still, even moderately sized paper remained more absorbent than silk and allowed for a broader range of dynamic effects, both wet and dry, than could be obtained on silk (figs. 29, 32). It was the ideal medium for the freer, sketchy styles that dominated Chinese art after the thirteenth century.

Ceramics and lacquer. Two other important grounds for painting should be mentioned, although they have usually been associated with the decorative arts, outside the primary tradition of Chinese painting. The earliest of all Chinese paintings are found on ceramic wares, part of an artistic tradition that persisted throughout the neolithic period from the late fifth into the early second millennium B.C. (fig. 35). A variety of regional styles have become recognizable, many of them superlative in quality by the standards of neolithic art. While they primarily constitute a geometrically abstract tradition with little direct relation to the later traditions of pictorial representation, these ceramic wares display the earliest use of a soft-haired painting brush, and express the Chinese characteristic love of dynamic flowing lines. In later times, during much of the

present millennium, Chinese ceramic wares provided one of the few major outlets for painting as a popular folk art.

The superb Chinese tradition of lacquer painting flourished in the late Chou and Han periods (fig. 36). Lacquer is the sap of the lac tree, which grows primarily in southern and western China. It is a clear liquid, poisonous in the manner of poison ivy or poison oak, and is a naturally-occurring polymer, or plastic. Already in the Shang period, the process had begun of building up multiple layers of lacquer over a wafer-thin core of wood or cloth to produce a lightweight, water-resistant, yet extremely sturdy, ware.[6] Late Chou and Han painted lacquer wares took the form of boxes, bowls, food utensils, large ceremonial vessels, and even full-sized burial caskets. Painted designs were added to the uppermost layer of lacquer, using black and red lacquer- or oil-based pigments, sometimes adding green or yellow. Ancient texts and inscriptions distinguished between those craftsmen who produced the ware itself and the artists who painted the designs. The sticky lacquer sap used as a base for the artists' pigments encouraged slow, elongated movement of the brush and contributed to the attenuated, elegant character of many of the finest designs. Late Chou and Han painted lacquer designs contributed not only to the abstract decor of inlaid bronze vessels, but to the vocabulary of the infant art of landscape painting as well (figs. 36a, 10n). As our knowledge develops, we will become more able to integrate painted lacquer and ceramic wares into the study of the major painting traditions.[7]

Related media. Owing to the great rarity of pre-Sung paintings, art historians often pay close attention to more permanent art forms which drew their designs from painting. Bronze decor occasionally seems to qualify (fig. 9), as does some of the sculpture done within the rigorously codified canons of Buddhist art (fig. 16). More useful still are designs engraved in stone. Stone panels, not uncommon in Han and later tombs, displayed incised linear designs, or backgrounds carved away allowing the primary figures to stand out in raised relief, or both techniques combined (fig. 11). Since early times, the Chinese recorded important proclamations and conveyed permanence to valuable works of calligraphy and painting, originally created in other media, by copying them in stone (figs. 3-5, 7, 17). Chinese stone-cutters were masters of such copy work, reproducing effectively even the stray marks left by the hairs of the brush.

By the Sung period, multiple reproductions of these carved works were produced through a process known as "rubbing" or "ink-squeeze." Both wet and dry techniques existed for taking a rubbing, but the latter was more common. In this process, a sheet of paper was moistened with a solution of starch (agar-agar), then placed upon the surface to be reproduced. It was tapped with a soft mallet until it adhered tightly and until the paper had been worked slightly into the incised recesses of the stone surface. Then the surface of the paper was rubbed with an inked pad. Those areas of paper recessed into the engraved portions of the stone remained untouched by the pad; they alone remained white while all the surrounding paper was inked black. Many calligraphic specimens and some important painted designs have been preserved today only as a result of this method. The quality of such reproductions depends on the skill of the one taking the rubbing, on the quality of the stone carving, and on the condition of the stone, which degenerates with repeated rubbings. Not uncommonly, an important engraving deteriorated greatly through frequent rubbing. It was then copied onto a new stone, sometimes on more than one occasion (figs. 5, 7). In the process, the original style might subtly be altered by the historical preconceptions of the copyist, who also functioned as a restorer. In some cases, a historical series of rubbings survives to docu-

ment the progressive alteration of an original style, from cutting to cutting. Thus, while seemingly permanent in form, carved stone and ink rubbings need to be treated by the historian with the same caution required by all artistic copywork.[8]

Seals

The last materials to consider are the seals of painters and collectors, whose marks are apparent on most Chinese paintings (fig. 32a). The purpose of a seal, which consisted of an impression made with a carved stone and red sealing paste, was to certify authorship or ownership. Most seals gave the seal owner's personal or literary name, the name of his studio, or an identifying literary expression. Although seals first became popular with their application to documents in the late Chou and Ch'in periods, their earliest recorded appearance on paintings occurred much later, with two small inventory seals used to register works in the collection of the second T'ang emperor (ruled A.D. 627-50). And only in the Sung period, as the early anonymity of artisan painters increasingly gave way to a concern for artistic individuality, did painters begin to apply seals to their own works (fig. 21h).

Most often square or round, sometimes gourd-shaped (fig. 20), seal designs were cut into a soft stone, such as soapstone. The seal was applied with a waxy, oil-based ink, colored red with powdered cinnabar. If the characters were incised, they appear white in the impression; if carved in relief, they appear red. The style of script used for seals was that practiced during the late Chou and the Ch'in periods, when seals first became popular. Soon afterwards supplanted by another script style, but kept alive as an archaic style primarily for use in such seals, this calligraphic script came simply to be known as the "seal script." The majority of seals range from one-half inch to an inch-and-a-quarter in height, allowing one to roughly gauge the scale of a work seen only in photographic reproduction.

It might be argued that such seals are really external to the work of art and should be visually swept away by the viewer, especially since collectors continued to add seal impressions for many hundreds of years after the execution of the painting. But from the Chinese point of view, this continuous accretion lent honor to the work and kept it alive as an organic, growing form. The presence of the seals of past collectors, whose personalities and tastes often remained well-known in later times and some of whom were themselves important painters, was a matter of deep enjoyment for the present owner, who felt a relationship with them that crossed the barrier of time. The addition of seals helps modern scholars to determine the later history of a painting, to know who saw and owned it, and to judge which later artists might have been influenced directly by it. Art historians also use seals as an important tool to authenticate works of art, but it should be noted that, like paintings and signatures themselves, seals were sometimes copied or forged (such as those on figure 20), and the detection of this requires special expertise.[9]

Format

The physical format in which a painting was presented helped condition its artistic style, as well as contributing to its historical fate.

Wall paintings. Wall paintings presented a large, flat surface, usually meant to be viewed from afar in a public, rather than a private, setting. Most often, they called forth broad and readily apparent designs, painted with powerful brushwork and bright, highly visible colors. Great subtlety of brushwork, while possible, was not encouraged by this format, nor was privacy in execution or intimacy in viewing characteristic of it. When, in the mid-Sung period, cultivated tastes turned from heroic monumentality to lyricism or scholarly understatement, and the production and viewing of paintings became an increasingly personal or private affair, this format finally yielded its foremost position to others associated with painting on silk and paper. Although wall paintings were created in great numbers from Han times through the Sung, few ancient Chinese buildings have survived—aside from the numerous Buddhist paintings in the caves of Tun-huang (fig.16)—and an ancient wall painting is a great rarity. Only in the past two decades have excavated tombs, while offering a selective view, begun to show us wall paintings from the metropolitan centers of early Chinese culture.

Screens. Large, free-standing screens were an essential part of Chinese interior architecture. They were often decorated with paintings on silk, or else, as was probably more common in early times, the paintings were applied directly to wooden panels prepared with gesso. Screens commonly took the form of a single large panel raised above the ground on legs (fig. 23g), or of multiple vertical panels lashed together as a folding screen. As early as the Han Dynasty, in formal interior settings, screens were placed behind the host or his honored guests to denote their lofty status. In addition, screens served indoors as room dividers and outdoors as windbreaks. Also included in the category of painted screens were the single panels attached to the sides of couches (fig. 23c), beds, and palanquins. Treated as household fixtures, screen paintings were subject to rapid deterioration and frequent replacement. Like other furnishings, they were often discarded with changes in vogue rather than being preserved as antiques, as scroll paintings were. Thus, virtually the only early screen paintings handed down to the present time are a few that were remounted as hanging scrolls, none of them from before the tenth century; the only exceptions are ones excavated in recent years.[10]

Handscroll. The handscroll or horizontal scroll was a hand-held, intimate, easily stored and transported alternative to the more imposing wall and screen paintings of early times (figs. 18, 26). It seems to have developed naturally out of the form in which written documents were kept in the Chou period, on thin, vertical bamboo slips that were bound together in right-to-left sequence and rolled up for storage (fig. 37).[11] The continuous-narrative form taken by Buddhist illustrations transmitted from India may also have contributed. The earliest use of handscrolls was for writing, and painting in this format probably originated with illustrations to written texts. Early illustrated examples included those laid out with alternating passages of text and illustration, as well as others in which the text appeared below, the painting above, each without interruption.

Handscroll paintings ranged from less than three feet to more than thirty feet in length; the majority were between nine and fourteen inches high. Paintings were mounted on a stiff paper backing; those of greater length were often painted on several sections of silk or paper joined together (fig. 1a). At the left was attached a round wooden roller (fig. 1c), about which the scroll was wound when not in use and which was occasionally decorated with a knob of ivory or jade. At the right was a semi-circular wooden stave (fig. 1d) which kept the scroll properly stretched from top to bottom.

The painting was viewed from right to left, as one reads in Chinese, unrolling a bit at a time from the roller and transferring the excess to a loose roll temporarily maintained around the stretcher on the right. About one arm's length was exposed at a time for viewing. Usually, a title sheet was inserted at the beginning (fig. 1f), and a long roll of paper was placed at the end of the scroll (fig. 1h). The end roll kept the painting from having to be coiled so tightly around the roller, for better preservation, and inscriptions were written on it by the artist and by later owners and viewers. These calligraphic inscriptions consisted of appreciative and historical notes, often adding considerable interest and significance to the work as a whole.

The great distinction between the handscroll and all other formats is its considerable length and its sequential exposure of the painting, allowing the artist to control the pace of visual events and to manipulate the viewer's response with shifts in subject matter and treatment. In the depiction of landscape (fig. 26), the artist might speed the viewer over smooth or rugged passages, create a sudden halt, and alternate close-up, specific views with others far away and dimly seen. The handscroll format, among the greatest of Chinese contributions to the art of painting, comes as close as any pre-modern device to the effect of the motion picture, in which the sequential development and pacing of events are of the essence.

Hanging scroll. Hanging scrolls were suspended on walls and served as small-scale, changeable wall paintings (figs. 21, 22, 23b, 24, 25, 31, 32). Like the handscroll and in contrast to wall and screen paintings, they were light in weight and conveniently rolled up for storage, so that they survive today in large numbers. However, like wall paintings and unlike the handscroll, they display their entire composition at one time. The artist had to achieve both a clear and unified design, best appreciated from afar, as well as presenting subtle detail in line and texture to be inspected close at hand.

Not yet mentioned in sixth century texts but apparent by the ninth, the hanging scroll came into full prominence in the tenth century. Its origins are uncertain. Although scholars have long believed that the hanging scroll format was derived from the tall banners brought with Buddhism from Central Asia into China, the recent discovery of Chinese banner paintings from the second (fig. 10) and first centuries B.C., long before the advent of Buddhism, may suggest a less simple solution. The hanging scroll is not unlike an individual panel from a folding screen in proportions, so it might also be viewed as the marriage of that vertical layout with the principles of the handscroll, designed to permit variety in presentation and safety in storing the painting.

The mounting of a hanging scroll included a heavy paper backing plus a decorative surrounding fabric frame, often elaborated into several panels of differently colored, patterned silks (fig. 1b). At the top of the scroll was attached a semi-circular wooden stretcher (fig. 1d), to which was tied a loop of ribbon for hanging the scroll. At the bottom, a roller (fig. 1c) served as a weight for the painting when hung and when not in use was the core around which the painting was gathered. Generally, the height of hanging scroll paintings ranged from two to six feet, although some ten foot giants existed. This format tended naturally to stimulate designs that took advantage of its verticality, and the emergence of the hanging scroll at the same time as the monumental landscape style approached its peak of splendor perhaps indicates a mutual influence between style and format (fig. 21).

Album. The album first emerged as a format for painting during the Sung Dynasty. Its origins lay in bookbinding processes that developed with the woodblock printing of

texts, emerging in the T'ang and becoming widespread in the Sung. The form was primarily a matter of convenience: when literature was mounted in scroll form, material toward the end of a text could only be reached by unrolling the scroll from the beginning, which became a lengthy process in the case of a longer scroll. By taking the same continuous stretch of silk or paper and folding it together in accordion manner rather than rolling it up (fig. 1i, j), it was possible to open it immediately to any section of the text. The particular format that emerged was shaped by the way that Chinese printed pages were made—on single, large blocks of wood, rather than with individual, moveable characters—and by the size block that proved most convenient for cutting and handling, which became standard in the Sung period. This size block produced a horizontal sheet that was folded down the middle and mounted on heavy paper backing, accordion-style, as a double-paged album leaf (fig. 1i). In painting, single-paged facing leaves, often pairing calligraphy and painting, also became common (fig. 1j), sometimes mounted individually in a so-called "butterfly" binding (fig. 1k). Leaves were usually combined in groups of eight, ten, twelve, sixteen, twenty, or twenty-four. The album leaf had the further advantage of eliminating the continual wear imposed upon the silk or paper, ink and pigments, by the constant rolling and unrolling of a scroll.

The album leaf provided the artist with a small-scale format for the presentation of a single, unified scene, without the extensive demands of the hanging scroll and long handscroll. The album quickly became a popular format among artists of the Southern Sung period, as tastes turned from the monumental style of Northern Sung (fig. 21) to a more lyrical and intimate mode (fig. 27). The album also became popular among the scholar-amateurs, beginning in the late Northern Sung, who preferred small, casual study-sketches to the grand and highly polished professional styles, and for whom the album carried literary associations (figs. 33, 34).

Fan. Painted fans came in two major forms. The screen fan (fig. 1l) consisted of a single piece of silk, round or ovoid in shape, kept rigid by a circular outer frame attached to a bamboo or wooden handle. Fifth century inventories included calligraphically inscribed fans that were probably of this type, and painted fans must also have existed by then.[12] Large ceremonial versions of the screen fan, with long handles, were common through the T'ang period, as shown in paintings of the time. The greatest age of fan painting, employing the screen-type fan, began in the late Northern Sung and continued on through the Southern Sung period, twelfth to thirteenth centuries. Like the album leaf, this small-scale format provided an ideal vehicle for the refined and gentle taste of this period, sometimes expressed minimally with suggestive washes of ink, sometimes with exquisitely miniaturized detail (fig. 23).

A second type of fan was the curved folding fan (1m). This type was mounted on long thin ribs of bamboo, wood, or ivory, radiating from a point below the painting and joined so the fan could be closed in accordion manner. The folding fan was known to the Chinese by the tenth century, when it was brought from Japan, its place of origin, by Buddhist monks. But not until the fifteenth century, when it was re-introduced from Korea, did the folding fan become popular in China. The stiff fan was typically made of silk, the folding fan of paper. Quite common in both cases was the practice of combining a painted side with a backside of calligraphically inscribed poetry. Meant to chase away the summer's heat, fans were often painted with themes of boating or cool shade. Their predictable association with the more decorative styles of painting made them a somewhat less popular format among the amateur artists than among the professionals.

Altered formats. The present format of a work is not always its original one, and several types of change were most common: screen paintings were turned into hanging scrolls; handscrolls were cut up and remounted as hanging scrolls (figs. 20, 29) or as sequential albums; album leaves were remounted as handscrolls (fig. 33) or as hanging scrolls; and fan paintings had their frames removed and were gathered into albums (fig. 23).

The Elements of Painting

There are four aspects of Chinese painting style—line, wash, color, and texture—which one may think of as the building blocks or elements of composition. Line refers to an individual stroke made by the brush, where the natural width of the brush limits the width of the line, and where such qualities as the length of the line, its roundness or angularity, its evenness or changing width, all reveal the movements made by the brush in the hand of the artist. Wash refers to ink or colored pigments spead broadly over the silk or paper with movements of the brush that overlap and disguise the individual brushstrokes. Color refers to the hue of the artist's pigments (whether red or brown, yellow or blue) as well as to their tone (light or dark) and saturation (bright or dull). Texture refers to the effects determined by the wetness or dryness of ink as well as to visual factors resulting from the hairiness of the brush and the grain of silk and paper. Composition, which will be discussed in subsequent chapters, proceeds from the arrangement of these elements into composite shapes and broad designs.

Line (in Calligraphy and Painting)

Many Chinese paintings relied so heavily on line that they might better be refered to as drawings or sketches. From the earliest times, Chinese painting tended to present simple, clearly outlined shapes against an unpainted background, concentrating on the primary figures rather than on creating a total environment (figs. 10, 15). Artists did not attempt to construct, as the eye sees, a continuous patchwork of lighted, colored surfaces. The spatial environment, rather than being fully described, was suggested through relationships between the selected objects. Individual objects were viewed primarily in terms of outline; any treatment of the surface was secondary. From literature as early as the fifth century B.C., it may be inferred that the artists who painted the walls and decorated the regalia of the royal court already formed separate groups of craftsmen: first came those who drew the outlines, then came those who applied the color.[1] Apparently, those who worked first, drawing the lines that provided the painting with its basic compositional structure, were artisans of higher rank. Theoretically, a "line" need not actually be painted or described; the juxtaposition of two contrasting color areas creates an implied line, perhaps more mathematically "pure," being one-dimensional and lacking any width (fig. 10e). But in Chinese painting we are usually confronted with described lines, painted by a brush of visible width and thus having its own two-dimensional shape, an inner surface area and outer edges. Moreover, lines were usually painted with black ink, and color was commonly limited to interior areas.

Throughout most of the present millennium, the tendency to work primarily in terms of line was furthered by the increasing association of painting with calligraphy, promoted by the transition of Chinese painting from an initial period dominated by skilled, professional illustrators (figs. 12, 15, 22) to a period highlighted by the work of

amateurs, members of the Chinese scholarly elite (figs. 30-34). Calligraphy and poetry had long been the cultural staple of China's gentry, but not until the Northern Sung period did painting become fully legitimized as one of their regular leisure activities. These artists and their successors developed artistic styles in which both outline and interior description were based on gathered lines of ink, further reducing the importance of wash and color in Chinese painting. Their individual brushstrokes, generated from the techniques of calligraphy, were often of a complicated nature and brought a heightened level of visual activity to the painting surface (fig. 31). That Chinese painting became dependent on calligraphy is evident not only in painting itself but also in much of Chinese art criticism, where aesthetic concepts and terminology were often developed first in the area of calligraphy and later adapted to painting. Given this close relationship between painted and written lines, let us begin our examination of brushline with some calligraphic examples.

We have already mentioned a calligraphic type called seal script, *chuan-shu*, actually a variety of related ancient styles prevalent in the Chou and Ch'in periods and perpetuated later in the seals of painters and collectors. Let us compare an example of this script type (fig. 3) with the one which supplanted it in the Han period, *li-shu*, the official or clerical script (fig. 4). (These two examples are actually rubbings of stone engravings, but I will refer to them as if done by the brush which they copy.) In the former case, the lines are relatively thin and their width is virtually unmodulated through the full length of the stroke (fig. 3c). The beginnings and ends of individual brushstrokes tend to be rounded rather than pointed (fig. 3d). In most cases, where a line moves around a corner its path is curved rather than angular (fig. 3e). In contrast to this, the individual strokes that appear in clerical script are thicker and they are modulated in width as the brush moves from beginning to end of the line (fig. 4b). The strokes sometimes begin and often end with a point (fig. 4a, b). Corners are often angled sharply (fig. 4d) or flattened out (fig. 4g). In seal script, if one draws an imaginary dotted line down the center of each brushstroke, the ink would be arranged symmetrically on either side of this line (fig. 3b). In the clerical script, the thickening and thinning of the strokes often occurs asymmetrically about such an imaginary center line (fig. 4c).

How are such lines produced? We mentioned earlier that the typical brush is characterized by a tapered shape, thicker across the belly and narrowly pointed at the tip (fig. 2a). Held with the handle in a vertical position (fig. 2b), when the brush is lowered towards the silk or paper, it first makes contact with its tip. As the brush is lowered further onto the surface, the thicker belly of the brush begins to make contact and the width of line increases (fig. 2d-e). The thickening and thinning of a brushline is largely produced by the lowering and raising of the entire brush toward and away from the surface. An unmodulated line is characterized by an unchanging distance maintained between the brush and the writing surface as the hand moves along the stroke (hand and arm moving as one). The seal script is characterized by this very steady hand motion, the brush moving horizontally only, to prevent any modulation of stroke thickness. In contrast, the clerical script emphasizes a lifting and pressing motion, especially in the concluding stroke of many characters where exaggerated pressure is followed by a rapid lifting of the brush away from the surface (fig. 2e-f).

A second aspect of brush movement to note is that exposed points at the beginnings and ends of strokes represent traces left by the thin tip of the brush as it first touches down (fig. 2d) and last leaves (fig. 2f) the writing surface. Such points can be avoided by causing the tip to leave its initial and concluding marks in areas that are subsequently covered over by traces of the thicker belly of the brush, and this is accom-

plished by a slight contrary movement at the beginning and ending of the stroke (fig. 2h-j). That is to say, if the stroke is to move from left to right in its general direction (as it ordinarily does in a horizontal stroke), the tip is first forced to the right of the brush by a brief initial leftward movement as the tip makes contact with the surface, exposing the belly toward the left of the tip (fig. 2h); then, as the brush begins its ordinary left-to-right motion, it is the belly of the brush that seems to have made the initial impression as the mark left by the tip is brushed over. A similar backwards motion may occur at the end of the stroke (fig. 2j). This technique is called "hiding the head" and "concealing the tail." Seal script demands this concealing technique, while the clerical script prefers, instead, to emphasize an angular conclusion to many of its strokes, still exposing the tip as the brush leaves the writing surface. Concealing the tip often requires a slightly slower, more cautious effort; a more aggressive motion is displayed in exposing the tip, emphasizing unbroken forward momentum. In calligraphy, a dot should be regarded simply as an abbreviated line, for in its construction the same principles of concealing and exposing are consistently applied (fig. 2g, k).

We have also noted that in moving around a corner, the brush may leave a well-rounded (fig. 3e) or angular track, pointed (fig. 4d) or flattened out (fig. 4g). The former effect is produced by carefully keeping the tip of the brush within the center of the brush track as it swings through the corner, leaving it round and smooth (2l-m). The angular shape is produced by a two-part movement: (1) pivoting the brush to expose the tip as the line comes to the end of the horizontal movement (fig. 2n-o); (2) without actually removing the tip from the surface, lifting the brush upwards and back just slightly, then pressing down and initiating a descending movement that leaves exposed the mark of the tip made at the corner of the stroke (fig. 2 o-p). Such complex movements as this became habitual in a calligrapher's practice and, in actual writing, were usually executed too fast to be easily observed.

When the track of a brush is symmetrically arranged around the imaginary line drawn through the stroke, it is due to the tip having followed directly behind the belly in its forward motion (fig. 2l-m). Brushstrokes of the seal script always exhibit this carefully maintained symmetry. To facilitate this, the brush is kept in a strictly upright position (fig. 2b). On the other hand, if the tip is forced to the outer edge of the stroke by a slight rotation of the brush, so that the tip and belly are no longer in alignment with the direction of the stroke, any downward pressure of the brush will result in an asymmetrical thickening wherever the belly of the brush is further exposed (fig. 2q-s). All of the thickening will occur on the belly side of the central axis, while the tip rides evenly along near the upper edge of the line. This kind of stroke is especially emphasized in the clerical script, where in order to expose the side of the brush to the paper, the brush may be held somewhat aslant (cf. fig. 2c).

Knowing full well from their daily experience the behavior of the brush, Chinese critics had no need for such formal explanations as these. Instead, they preferred to describe in poetic terms the dynamic qualities of brushwork. Most famous was the early description of the basic types of brushstrokes traditionally attributed to Lady Wei of the fourth century A.D., which included these four types: ". . . like a cloud formation stretching 300 miles, indistinct but not without form . . . like a big stone falling from a high peak, rebounding and crashing, about to shatter . . . a withered vine a thousand years old . . . the sinews and joints of a mighty bow."[2] To fully appreciate brushwork, we must understand the relationship of shapes, brush motion, and artistic energy. When we look at Lady Wei's descriptions, ". . . like a big stone falling from a high peak, rebounding and crashing, about to shatter . . . like the sinews and joints of a mighty

bow," we are reading a kinesthetic vocabulary which describes both movement ("rebounding and crashing") and stored up, potential energy ("about to shatter," "a mighty bow"). In clerical script, we can easily see the active "rebounding" of the brush as it rhythmically rises and falls (fig. 4b). This is energy expressed, released by the artist. In contrast, the seal script is plain, understated. The brush moves carefully, though any hesitation or nervousness will readily mar its perfectly even character. Seal script has its own dynamic, requiring smooth, steady discipline and perfect calm. In Chinese aesthetics, such calmness was as much appreciated as dynamic action and regarded as a sign of strength rather than an indication of weakness. Rather than releasing energy, the seal script seems to store it up as potential, like the potential of a mighty bow whose subtle curve expresses tautness and the ability to spring instantly into motion. Accordingly, the seal script was attributed a wiry quality, taut as metal though smoothly rounded (fig. 3e). It should be noted that when the seal script was first used, the brush was still primitive, probably blunt-tipped, not yet multiple-layered, and rather inflexible, and that clerical script developed in conjunction with the emergence of the typical "modern" Chinese brush. Seal script is difficult to execute with the flexible brush and is more readily executed with a soft brush, whereas the clerical style takes full advantage of a stiffer, springy brush.

Since much of the appreciation of Chinese painting derives from a cultivated sensitivity to brush dynamics, let us further refine and amplify these observations with another comparison drawn from calligraphy, taking two works executed in the regular script, k'ai-shu (figs. 5, 6). This script was the historical successor to clerical script, the last of the script types to evolve and the standard form of writing from the Six Dynasties until the present day. Regular script differs from clerical script less in terms of brush dynamics and more in its compositional principles, to be discussed in a later chapter. Though both of these examples adhere to the structural principles of regular script, they nevertheless show the range of brush dynamics to be found within this script; they might be thought of as individual styles within a standardized compositional type. One of these examples reproduces a text written in A.D. 220 by Chung Yu, the first great practitioner of regular script (fig. 5).[3] Chung Yu's work exemplifies the ideals of regular script style, in that the brush is held vertically (fig. 2b), the tip remains more centered within the stroke than it does in clerical script (figs. 5b, c, 4a, d), and the strokes exhibit a shift from the angularity of clerical script to a more softly rounded mode. In this work, the modulation of brush width is everywhere in evidence yet always held in restraint, done with an undulating motion of the brush, in rhythms smooth and graceful. The calligrapher's hand is light and buoyant, pressing slightly backwards at the beginning of many strokes, lifting slightly as the brush picks up forward speed, then slowing down and pressing gently once again before lifting away from the writing surface (fig. 5e). The slightly lean strokes are precise and clear, their heads and tails smoothly rounded, well hidden (fig. 5c) except where a concluding point is demanded by the script type (fig. 5d).

Chung Yu's calligraphy achieves a rare level of relaxed, natural discipline. An entirely different, emotionally arousing effect is achieved in the second example, by Yeh-lü Ch'u-ts'ai (fig. 6), whose strokes are complex and irregular in shape, broad and muscular in proportion, and forceful in their forward movement. Structurally, his characters are regular script in type, but his strokes move with the power often associated with clerical script. The brush is thrust into the writing surface and continues to bear down through the full length of the stroke. Many of the strokes seem to sweep and slice (fig. 6e), some are blunt and contracted jabs (fig. 6d), and everywhere their rugged char-

acter and chance effects contrast with the controlled, regular undulations of Chung Yu's work. Brush "lines" have their own outer lines, and particularly noticeable in Yeh-lü's work is the ragged edge given many of these strokes, where his hand sometimes trembles with pent up energy (fig. 6b) and the stray hairs of his large, somewhat worn brush (fig. 6c) create a complex, sometimes unclear boundary. The splitting of brush hairs is the effect of rapid, unhesitating brushwork. As the brush moves more rapidly than the ink is able to flow from it, the hairs of the brush tip temporarily dry and clump together, splitting apart and leaving a set of parallel tracks (fig. 6a). This streaked effect is known as "flying white," the fast flying brush allowing the white writing surface to be partially exposed. The effect, occurring at the end of the stroke and perhaps accentuated by a slight flip of the wrist, is a good indicator of the direction of the brush movement.

We have used the Western term "calligraphy" (literally, "beautiful writing") to describe Chinese writing when raised to the level of a fine art, but the Chinese used a term *shu-fa* or "models for writing," which emphasizes a concern for something other than beauty—namely, tradition. Great works were designated as models from which students learned, and artists spent many patient years copying such works before consciously developing their own manner. Later works usually drew humbly from models of the past and achieved individuality by producing new variations on old themes. In a society which revered tradition more than originality, and in which photographic reproduction had not been dreamt of, patient copywork was both the basic route to artistic improvement as well as a ready means of making famous works available to a larger audience. In painting as well as calligraphy, early training depended upon copywork, and paintings which deviated too far from a copyable linear standard (e.g., fig. 29) were sometimes chastised as heterodox, straying from traditional ideals. To gain some appreciation of this Chinese artistic ideal, and the generation of originality through variations on past models, let us choose two closely related examples written in the draft script (*ts'ao-shu*, a cursive form of the regular script, sometimes referred to as "grass script"), which will complete our initial survey of the four basic written styles (figs. 7, 8).[4]

China's most famous calligrapher was Wang Hsi-chih, who lived in the fourth century A.D. and was among the first to elevate handwriting from purely practical use to artistic status. Works by him have survived mainly in copies and rubbings, no doubt with some modification of their original form. In one of these, we can compare Wang's abbreviated, cursive script (fig. 7i) with the equivalent characters in the regular script (fig. 7h), written directly upon the rubbing to the right of Wang's own calligraphy.[5] In Wang's calligraphy, the tip of the brush is allowed to flick out at the beginnings and ends of some strokes (fig. 7g), but the strokes remain full and, usually, the ends of the strokes and the corners are well-rounded (fig. 7b). Wang's lines have been likened to floating ribbons twisting in a gentle breeze, and when one follows the path of his brush, its flow may be sensed as relaxed and loose. This quality is better appreciated when compared to the work of Sung K'o (fig. 8), a close follower of Wang's style some one thousand years later, but whose brush has a more taut and springy motion. Let us isolate two simple words which occur in both texts. The first character (figs. 7d, 8f) means "to write" (it is the *shu* of *ts'ao-shu* and *shu-fa*) and is composed of two separate

strokes, 丿 and 乙 , combined as � . The beginnings of Wang's strokes may expose

the tip of the brush (fig. 7c) but in general they are quite plain in form compared to Sung's,

whose strokes begin instead with an elaborate thickening of the line (fig. 8g, h). Sung's first stroke begins thick, thins out, and ends with a knob-like projection. Such complexity is not manifest in Wang's version. In moves quite different from Wang's, Sung's second stroke begins with a springing pressure-release movement (fig. 8h), stretches somewhat exaggeratedly toward the first turn (fig. 8i) in order to whip back more dramatically, then thins and sharply thickens again at the second curve (fig. 8j). A final move is made with a rapid motion that allows the hairs of the brush to spread and expose the white writing surface (fig. 8k), emphasizing the climax of a dashing composition.

Next, contrast the character meaning "sun" or "day," found in both texts (figs. 7e, 8b) and written with two strokes ❙ ,𝄞, which are combined as 𝄞. In the second of these strokes, as written by Wang, the upper right corner is all but eliminated (fig. 7f) and the stroke is composed of one compact and evenly curving move of the brush, which from start to finish aims toward its goal with direct simplicity. In Sung's version, several distinct, extended movements of the brush can be seen, and the changes of direction are more sudden. The second stroke moves exaggeratedly toward the upper right corner (fig. 8d), allowing the downward movement to be longer and more powerful. In contrast, the remainder of the stroke (fig. 8c) is thin, including an abrupt turn of the brush at the lower right corner, then two more sharp turns and a hair-thin line which leads into the beginning of the subsequent character (fig. 8e). Wang's written character is considerably more abbreviated, more reserved physically and calmer in mood. Throughout these abstract linear compositions, Wang's plain, soft manner contrasts with Sung's more tensely energetic, swirling effects, with his sudden transitions and tightly composed spirals, and with his linking together of two, sometimes three characters in succession (fig. 8a).

In search of differences, we have perhaps overlooked the essential similarity between Wang's work and Sung's, and the differences between them are subtle compared to those which separate Chung Yu from Yeh-lü Ch'u-ts'ai. Their historical relationship— a pattern which any student of Chinese culture must come to understand—should be regarded in terms of a style within a style within a style. Both works share the general stylistic characteristics of the cursive script, so formalized as to have become a set "type." Within the parameters of this script, they both adhere to the particular manner begun by Wang and followed by thousands of later adherents such as Sung K'o. Thus far, they are similar, much more so than any two calligraphic specimens picked at random. And yet within this essential similarity, Sung K'o has brought to Wang's tradition his own innate rhythm, quite different from Wang's. A trained viewer can see in his style "both Wang and not-Wang," variation within tradition. As one can see in these examples, style in Chinese calligraphy is based on past styles and every creative assertion comes in the form of a dialogue with history. Painting, similarly, has been termed an "art-historical art" and, like calligraphy, takes aesthetic delight in pursuing ever more subtle shades of variation on past models (figs. 21, 31).

In an "art-historical art," where the style of another master literally becomes the artist's subject matter, it is correspondingly harder to distinguish the artist's own unique style, and one must find it by subtracting those characteristics imposed by the historical style he has chosen to work within. For example, the works of Wang Hsi-chih and Chung Yu are obliged by their script types to be different, Chung Yu's strokes shorter and more angular, Wang's more continuous and rounded. Yet when this typological layer is stripped away, a remarkably close relationship is revealed. Above all, both are

distinguished by a special elegance, simple and smooth, relaxed and unpretentious. This similarity is no mere coincidence, for Chung Yu's style provided a model which Wang himself revered. These two artists are poles apart from the stylistic ideal of Yeh-lü Ch'u-ts'ai and of Yeh-lü's historical model, Yen Chen-ch'ing of the eighth century. Yen Chen-ch'ing supplanted the early Chinese ideal of perfected elegance with one of rugged naturalism, and opened new aesthetic vistas with awkward but emotionally revealing brushwork and unusual effects of ink, which critics likened to stains left on the underside of a leaky roof.[6]

For the Chinese, style was rooted not only in history but also in artistic personality. To look at a written composition or a painting, it was claimed, was to see the artist himself. There is a large dose of truth in this, and the works of Wang Hsi-chih and Chung Yu, Yeh-lü Ch'u-ts'ai and Sung K'o bear it out. Wang's love of scholarly leisure, far from the troubles of court, his taste for elegance tempered by a love of natural harmony, his mild and generous character are all well-known and entirely consistent with the style seen here. Chung Yu, while a major political figure, was essentially a man of similar temperament. Yeh-lü Ch'u-ts'ai, on the other hand, was an outspoken advisor to Genghis Khan, and he was no less bold in his handling of the brush. Sung K'o, although a learned scholar, was a rare and famed example of the "knight-errant" who rode the countryside sword in hand in pursuit of adventure and glory. Lean and athletic in his writing style, it is easy to imagine him wielding his brush like a rapier. Practitioners and connoisseurs of this abstract art regularly associated it with such personal qualities, and, above all, they appreciated sincerity of expression. Still, the relation between artistic style and human character should be treated cautiously, and we should neither imagine that artistic personality always corresponded to social personality nor that artistic personality was a predictable or consistent phenomenon.

Let us now turn to the use of line in painting, considering the contribution of linear forms and rhythms to the painting as a whole. Compare, for example, the depiction of two Buddhist priests, both historical figures of the seventh century (figs. 12, 25). One of these portrays a somewhat worldly priest, Pien-ts'ai, seated on the left, engaged in a duel of wits with the imperial courier Hsiao I, who has come surreptitiously to confiscate from the priest's collection of calligraphy a famous ancient scroll composed by Wang Hsi-chih and coveted by Hsiao I's patron, the second T'ang Dynasty emperor.[7] The lines in Pien-ts'ai's garments are all thin, elongated, and curved (fig. 12a); one looks in vain for a sharp angle. Done with an upright brush, the lines are virtually unmodulated in thickness except where the tapered point at their conclusion indicates the direction of the strokes (fig. 12d). The brushstrokes used to describe Pien-ts'ai's robe all have a primarily descriptive value, lacking any highly calligraphic or independently expressive quality of their own, and are perfectly appropriate for the definition of smooth-edged drapery folds. That these lines were consciously selected for a specific function is suggested by comparing them with the brushwork used to describe the rustic wood-and-thatch chair on which the priest is seated. The lines used there are all modulated in thickness: along the top of the arm-rests (fig. 12b), for example, we may see how the lower edge of the line, formed by the belly of the brush, now held diagonally (cf. fig. 2c), becomes quite ragged and contributes to the rough appearance of the wood. The mat on which he sits has been drawn with a complex twisting motion of the brush, the irregularity of line effectively suited to a tangled appearance (fig. 12e). The artist could, no doubt, have described the crude wooden chair using elongated, unmodulated strokes like those of the priest's robes, but he has enhanced the naturalistic effect

of his painting through the use of lines that are varied to express the qualities of the objects they describe.

The second painting of this pair of examples (fig. 25) depicts the priest Hui-neng, a founding patriarch of the Ch'an (Zen) Buddhist sect who taught that spiritual enlightenment must be found in daily life, not vicariously obtained in religious writings, and who is shown here purposely destroying a scroll of sacred literature.[8] The lines used to describe Hui-neng's robe are comparatively thick and angular. They are heavily modulated, frequently beginning with a thickened hook (fig. 25a, b) and often diminishing to a thin point at the ends of the strokes (fig. 25c). The agitated rising and falling of the artist's hand, at times slowing down as it digs into the paper, elsewhere speeding rapidly along, is in sharp contrast with the even pressure and tempo of drapery lines in the former painting. One might be reminded by this of the contrast between the restrained seal script and the more energetic clerical script. Brushline here has taken on a different function than in Hsiao I, adjusted not to visual realities but to emotional ones. In painting Hui-neng, the artist was less intent on descriptive representation than on reinforcing, through the use of abstract line, the dynamic activity of the figure represented. These two examples indicate something of the range in function and style of line in Chinese painting, varied and flexible enough to permit both the naturalist and the abstractionist to work comfortably within the confines of an essentially linear art form.

As in calligraphy, so too in painting, the historian's and connoisseur's attention to line often relates to their concern for the identification of individual styles. The painting *Hui-neng Tearing Sūtras* has, for centuries, hung as a pair with another painting which represents *Hui-neng Chopping Bamboo* (fig. 24), both attributed to the artist Liang K'ai. According to tradition, the latter represents the moment when Hui-neng attained spiritual enlightenment, an active moment and yet also one of profoundly quiet insight. Although basically similar, the brushwork used for these two portraits reveals some subtle and significant contrasts. Several lines in *Tearing Sūtras* begin with a knob-like projection (fig. 25a, b), the artist setting the brush onto the painting surface and then hesitating, momentarily, before moving on. This action is not characteristic of *Chopping Bamboo*, where the lines often commence with a strangely squared-away shape (fig. 24a), probably resulting from a worn-out, pointless brush, and then proceed without hesitation. More than a dozen strokes in *Tearing Sūtras* conclude with a long, tapered effect, exposing the tip of the brush at the end (fig. 25b, c); this frequently occurs in strokes that are physically isolated from all of the others. Such strokes have no clear counterpart in *Chopping Bamboo*. Many of the longer strokes in *Tearing Sūtras* are almost straight, the artist's hand moving directly toward a conclusion; in *Chopping Bamboo*, almost every line reveals a subtle curve, wrapping tightly around the priest's body and indicating a somewhat more descriptive intent (fig. 24b). Many of the strokes in *Chopping Bamboo* seem less forceful than those in *Tearing Sūtras*, yet most of them have a complexity and a sustained pattern of internal variation that is wholly lacking in the latter painting. *Chopping Bamboo* employs strokes that travel along more patiently, taking one last turn or slowing down and thickening before coming to a halt, seeming more to compress energy within the stroke than to release it. *Tearing Sūtras*, on the other hand, employs a more limited repertoire of brushstrokes, primarily emphasizing those that fully release the brush energy at the exposed tail of the stroke. Perhaps this contrast of contained versus released energy is consistent with an artist's attempt to juxtapose two emotionally different themes, one more contemplative *(Chopping Bamboo)*, the other totally extroverted and dynamic *(Tearing Sūtras)*.

And yet this subtle difference in brush manner has been sufficient to convince some experts that two different artists are represented here, *Tearing Sūtras* perhaps being a copy by a Japanese artist of a now-lost original by Liang K'ai.

The importance of line in Chinese painting is equivalent to that of color in European art. Before any representational image emerges, the line is already there, providing not only shape but aesthetic character. In *Ming-huang's Journey to Shu,* for example, the tight-skinned, block-like landscape forms are bound by firm outlines (fig. 19i), scarcely modulated save for the knob-like beginnings and tapered ends of some of the strokes (fig. 19e, f). Unmodulated brushwork is sometimes characterized as uncalligraphic (figs. 10, 15), but these brushstrokes have all the tensile strength that one finds in seal script (fig. 3) and impart to these forms an appearance of architectonic solidity. In contrast, the twisting dynamism with which Kuo Hsi's serpentine mountains awaken in *Early Spring* (fig. 21) emerges out of brushwork that is vibrant and rhythmic, not clearly or tightly bounding his forms but delivering movement and energy to them. Twisting and curling, modulated thick and thin, Kuo Hsi's brushwork, like cursive script (fig. 8), moves aggressively onto the belly of the brush to achieve its powerful, athletic effect. In Ni Tsan's landscape, *The Jung-hsi Studio* (fig. 32), the brushwork is so relaxed that the forms themselves seem immaterial. The strokes seem to float like light textile, with the side of the brush sometimes exposed in an uncalligraphic movement in order to make the line as indistinct as possible (figs. 32b, 2c). The bluntness and strength of line in Wu Chen, Wang Meng, Shen Chou, and Tao-chi (figs 30, 31, 33, 34) epitomize the literati cultivation of "unadorned virtue" and avoidance of anything pretty; contrast the subtle elegance of line in the academy painter Ma Lin's highly perfumed landscape (fig. 27). Some of these painted brushlines, in the process of becoming conventionalized models, came to be given their own characterizing names, such as the "iron-wire" tight brushwork popular in T'ang landscapes and imitated in *Ming-huang's Journey* (fig. 19); the "curling-cloud" of Kuo Hsi's *Early Spring* (fig. 21); the "folding-sash" of Ni Tsan's fabric-light strokes, which sometimes conclude with a short, folding L-shaped movement (fig. 32c); the "nail-head" and "rat-tail" beginnings and ends, noted earlier in *Hui-neng Tearing Sūtras* (fig. 25a-c), and, betraying a Sung date at the earliest, in the T'ang-derived *Ming-huang's Journey to Shu* (fig. 19e-f); the "axe-cut" stroke, providing a sense of rocky texture to the landscapes of Hsia Kuei (fig. 26e) and Ma Lin (fig. 27a), done with a sweeping, uncalligraphic movement on the side of the brush (cf. fig. 2c); and the extended "hemp-fiber" texture stroke, done rather like cursive script with an upright brush and a centered brush tip, somewhat flat and straight in Wu Chen's grassy-sloped mountains (fig. 30a), vigorously twisting as done by Wang Meng (fig. 31a). It should be noted that while some artists chose to work largely within the framework of calligraphically-derived brushstrokes (figs. 30, 31, 33), others did not, as a matter of artistic choice. The painter was free to apply the brush much more flexibly than the calligrapher, free to use "all four sides of the brush" (figs. 20, 26, 29).

Wash

In addition to the linear technique so prominent in most Chinese paintings, artists used a second basic manner of applying pigments or ink—not in thin, extended lines describing contours and edges, but in broad strokes that defined a surface area (fig. 22a). Unlike linear brushwork, in which individual brush movements left a clear record of

their path, this manner tended to disguise individual motions of the brush, blending many strokes together in order to unify a given area. Because the swept moved back and forth with wet ink or pigment (fig. 29), this technique was known as a "wash" of ink or color. A soft-haired brush was used for the application of a wash, a larger one if the area was large, and often the brush was held at an angle to expose a greater amount of its surface to the silk or paper.

Considerable variety was possible in the application of a wash. Historically, the wash seems first to have been used as a means of adding interior color to a basic description of objects already composed in ink outline (fig. 10f). Color washes helped to consolidate these areas visually, contrasting them with neighboring areas, sometimes heightening the sense of naturalism, and sometimes contributing forcefully to the abstract design. Generally, as used by early artists, color washes were distributed with perfect evenness over the silk (pl. 1, fig. 10f). As time brought greater diversity in painterly techniques and conception, irregularly distributed washes, multiple-layered washes, and washes of ink (rather than color) all enriched the vocabulary of visual styles. The eighth century saw tremendous technical innovations in the use of the wash. First came the layered ink wash, known as "broken-ink" *(p'o-mo)*. The broken-ink technique involved washes applied layer upon layer, carefully controlled in placement and coordinated in tone, with darker layers usually applied upon lighter layers (cf. fig. 27b). This technique permitted, for the first time, the modeling of seemingly solid forms and the achievement of rich, naturalistic effects (cf. fig. 21). Late in the eighth century came another technique, also pronounced *p'o-mo* though written differently in Chinese characters and meaning "splashed-ink" (cf. fig. 29). An unfettered celebration of the potential of wash technique, uncommitted to calligraphic line, splashed-ink relied on large quantities of ink that were often applied directly to the painting surface without the use of brush and gathered into pools as reservoirs for the sweeping brush. As much as the washes of the broken-ink technique were carefully controlled, the washes of the splashed-ink technique were irregular and left to chance. By the tenth century, there arose a colored-wash technique, in which layers of gradually modulated color washes were brushed on without any supporting linear structure or covered a pale underdrawing, hence referred to as *mo-ku*, "boneless" or "buried outline" (cf. pl. 4, fig. 22a).

Although the role of wash was diminished somewhat by the rise of the calligraphically oriented amateur style, most later painting continued to rely on the rich combination of line and wash (figs. 31, 33). Whereas the linear aspects of a painting draw our eye to the brush and to its movements in the hand of the artist, the use of wash emphasized the qualities of ink and pigment, their colors and textures. Although we have labeled brushline and wash as "elements" in this stylistic system, they cannot exist independently of color and texture, the next two elements to be considered.

Color

Very little has been written about the use of color in Chinese painting.[9] The Chinese traditionally discussed it much less than calligraphic line. Over the centuries, many artists held an active prejudice against the use of any significant degree of color in painting. This stemmed from two sources. First was an attitude that shaped Chinese intellectual life throughout the traditional period, prizing detachment from worldly things and the stilling of emotions. Color was seen as superficial, attractive, and base in

its appeal. Confucius deplored the court robes of his time as decadent for they had abandoned the pure colors, red and blue, in favor of mixed colors, purples and off-reds.[10] The Taoist classic, the *Tao-te ching*, saw most men as crazed by their love of beauty and pleasure and warned that "the five colors will blind the eye" to true perception.[11] Beginning in the eighth century, color was sometimes eliminated from painting as a means of bringing out the inner essence or spirit of the objects depicted. Even the Chinese language reinforced this negative attitude toward color, as the written word for it, *se*, also meant "beauty," "passion," "lewdness," and "anger." Chinese also has far fewer words than English to identify specific colors.

A second source for this negative attitude toward color, not entirely separate from the first, was the relationship of painting to calligraphy sought by those scholar-painters who preferred "writing out" sketches in ink and indulging in "ink play" to painting in color (figs. 30-33). After this scholarly mode came to dominate Chinese painting in the fourteenth century, the painting of ink bamboo became so common that the story was told of an eccentric artist who enjoyed painting bamboo in red, much to the surprise of his audience. When one disbelieving onlooker was asked what color bamboo *should be*, his answer was, "Black, of course."

Nevertheless, as much as half of all Chinese painting used some degree of color in addition to black. Before the Sung, the use of bright colors in painting was common (pl. 1). An early term for painting was *tan-ch'ing*, "the reds and blues," and during the T'ang period a mineral-based "blue-and-green" color scheme was so popular in landscape painting that any use of it in later times invariably recalled that earlier period (pls. 2, 3). More commonly in later times, the use of color was slight, a single delicate shade or two scattered about the work or limited to minor details (pls. 5, 6). But even with their sometimes negative attitude toward and limited use of color, Chinese artists often treated it sensitively, and a few, in pursuit of naturalism, demonstrated more than the obvious know-how in the use of colors (pl. 4). Rare, though important, was a master like Wang Yüan-ch'i, curator of the Ch'ing imperial collection of painting, who made color patterns a component of his dense compositional structure, complementing the force of abstract design with the rhythmic flow of color (pl. 3). In order to understand and describe both the naturalistic and abstract uses of color, we need to understand the nature of the element itself.

In place of a color theory based on natural observation, the traditional Chinese painter inherited a pedigreed system of color symbolism, in which five colors were designated as representing the cardinal points of the compass and the primal forces of nature. The south was symbolized by a red phoenix, readily associated with the tropical summer sun, while the north, the direction of the dark arctic winter, was associated with two black reptiles, snake and tortoise. A blue-green dragon stood for the east, direction of the ocean, while the western regions were symbolized by the white tiger that occupied their distant, upland slopes. The Chinese kingdom itself, the stable center of these cardinal points, was symbolized by a yellow dragon, while Heaven, like the north, was indicated by the color black. This categorical approach says much about the typical Chinese use of color in painting, which was to particularize it, isolate it against a neutral background, identify each object with its characteristic color, and severely limit the number of colors in use.

Although these five symbolic colors were chosen for other than naturalistic reasons, they correspond directly to the five colors held basic in Western color theory, in which all colored pigments may be generated through combinations of three primary hues, red, blue, and yellow, plus black and white (i.e., orange contains red and yellow, brown

is composed of orange and black, pink combines red and white). Black results from combining all three hues and white occurs in the absence of all. Chinese artists accepted the hues that natural vegetables and minerals provided. They did not attempt to adjust them to spectrally "true" reds and blues. They did not mix hues to achieve a closely related series of intermediate hues, as European oil painters so often did. Even in the highly naturalistic *Cat and Peonies* (pl. 4, fig. 22), where three different greens are carefully arranged close together (fig. 22b-d), the colors were not mixed by the artist but, fortuitously, were provided by the natural separation of the pigment malachite into three layers when dissolved in water. Typically, if the Chinese artist did mix hues, it was to obtain the one brown intended to go with the one blue of the painting (pl. 6).

There are two other aspects of color, in addition to hue, which are prominent in color theory: tone (or value) and saturation (or intensity). Tone refers to the relative lightness or darkness of a color. White itself represents the highest possible tonality and black the lowest. The addition of white to other hues raises their tonal value and is referred to as tinting; the addition of black lowers tonal value and is called shading.

One of the most striking features of Chinese painting is its integration of large tracts of unpainted silk or paper into the overall composition. Less obvious is the intrusion of the color of the ground into the applied colors and ink. Both of these factors contribute to the tonality and, in turn, to the general mood of the work. A white paper ground heightens the tonality of transparent colors, often giving them a charming pastel-like effect (pl. 3). Deep golden silk lowers tonality, contributing to the profound quiet of many richly atmospheric landscapes (pls. 4, 5, figs. 21, 27). In *Cat and Peonies*, we can see that the artist purposely chose the darker shades of malachite green for the upper sides of the peony leaves (pl. 4, fig. 22b) and distinguished the delicate undersides by carefully applying the palest tone (fig. 22c). Elsewhere, in constructing the flowers, he produced a gradually changing tonality not by selection but by a mixing process executed directly on the silk (fig. 22a). What he has mixed are lead white, the brown of the silk (which was prepared before painting with an overall wash of pale ink), and water, which regulates the transparency of the color solution. After a very pale underdrawing was laid down, white ink was placed along the outlines, toward the outer edges of the petals. Then, with a fresh brush, dipped in water but not in color, the pigment was spread toward the center of the blossom, becoming increasingly pale and very dilute by the end of the stroke. The result is, by any standard, an impressive example of tonal modeling.

Chinese artists were as greatly concerned with tonality as they were unconcerned with hues. Artists and connoisseurs regularly asserted that "if you have ink, you have all the five colors," and they largely validated this assertion with their successful exploration of black ink alone. Kuo Hsi, of the eleventh century imperial painting academy, was one of the foremost masters of ink monochrome landscapes and perhaps the first to leave detailed written comments on his painting techniques. In composing the earthen forms of *Early Spring*, he first established his basic linear outer contours (fig. 21e). Next, the eroded contours of the upper surface were defined by the addition of repeated layers of wet ink, applied with a twisting and curling motion of the brush, with darker lines indicating the upper ridges of the hills, paler tones spreading downward to round out the surface of the forms (fig. 21f). According to Kuo Hsi, the darker black lines were not differentiated from the lighter ones by the use of darker ink. Rather, pale ink only (mixed with a bit of blue) was prepared on the ink stone and was applied in six or seven dilute layers upon the silk. The final tonality of the darker areas, after evaporation, was the same as if more ink had initially been ground into solution

and applied all at once, but the process of going over the lines six or seven times with wet ink was preferred for its organic result, irregular in tone, blurred and suggestive rather than distinctly linear. Finally, Kuo covered the upper surface of the earthen forms with layers of carefully graded ink wash which turn pale and disappear as they move down the sides of the boulders (fig. 21g).[12] His mountain forms were likened to clouds because of their fully rounded, puffy quality, achieved without the use of colored pigments, and indeed they seem more cloud-like than the primitive, hard-edged clouds of Han and T'ang-like paintings (figs. 10h, 19g).

Saturation refers to the apparent purity of a color, sometimes spoken of as its intensity, or vividness. Take what seems to be an intense green, a very "green green"; tint it and it will become pale and washed out, shade it or mix it with most other hues and it will become dull. In *Cat and Peonies*, the artist differentiates between the dark upper sides of the leaves (pl. 4, fig. 22b) and their pale undersides (fig. 22c), but neither the darker nor paler color seems to be a particularly intense green. The most intensely colored spot in the painting is the red bow of a pampered housecat who runs loose in this setting (fig. 22f), leash still around its neck, and who seems utterly lost in curiosity over some bug or butterfly not visible to us. This one spot of red is but a small patch, but is fairly highly saturated and may catch our eye like a butterfly catches the eye of a cat. Probably derived from the upper layer of a cinnabar solution, this red seems more intense, a "redder red," than the somewhat darker red stamens of the flowers (fig. 22e), which were derived from the lower layer of cinnabar solution. Most of the colors of this work are not very saturated, and, generally speaking, most Chinese paintings, with the notable exception of "blue-and-green" landscapes (pl. 2), shied away from the use of bright, alluring colors.[13]

Texture

The last element to consider is texture, the surface characteristics of a painting, the sense of touch or feel of that surface. The word relates to textiles, describing their warp and weft, their raised and lowered pattern, their tight or loose weave, their smooth or coarse material. The fabric of a Chinese painting results from the combination and interpenetration of brush, pigments, and the surface of silk or paper. Silk, although sized, has a very regular, porous texture created by warp and weft (pl. 4). Sized paper has a much tighter, seemingly smooth surface, but has a very subtle small-scale texture based on its ground-vegetable content and on the vats in which it is dried. This texture is hard to see but may be brought to light by the play of brush and ink (fig. 32b). Ink has its own texture, moist and smoothly flowing under normal conditions (figs. 20b, d, 26c), but capable of spattering (fig. 28d) or of clumping into small grainy flecks when rubbed onto paper by a dry brush (fig. 32b). Even the brush leaves the trace of its texture under certain circumstances: when the brush begins to dry from lack of ink, when it moves so fast that the tip temporarily dries, causing the hairs to cling together, or when sweeping motions are made on the side of the brush, moving against the grain of the brush hairs (fig. 26e, cf. fig. 2c).

Chinese painters and connoisseurs were quite sensitive to texture. The seventeenth century painter-critic, Kung Hsien, justified his preference for two contemporary artists over all others on the basis of their textural qualities, a study in contrasts: the paintings of one, densely textured with dry brushwork, were likened to "coarse clothing and

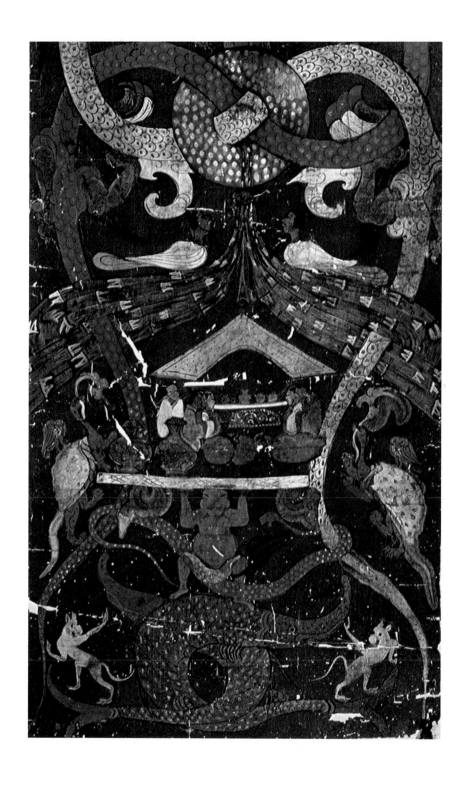

Plate 1. Anonymous. Funeral banner, detail, from Ma-wang-tui Han tomb number 1, Hunan Province. Ca. 165 B.C. Ink and colors on silk. Hunan Provincial Museum, Changsha. (See also fig. 10.)

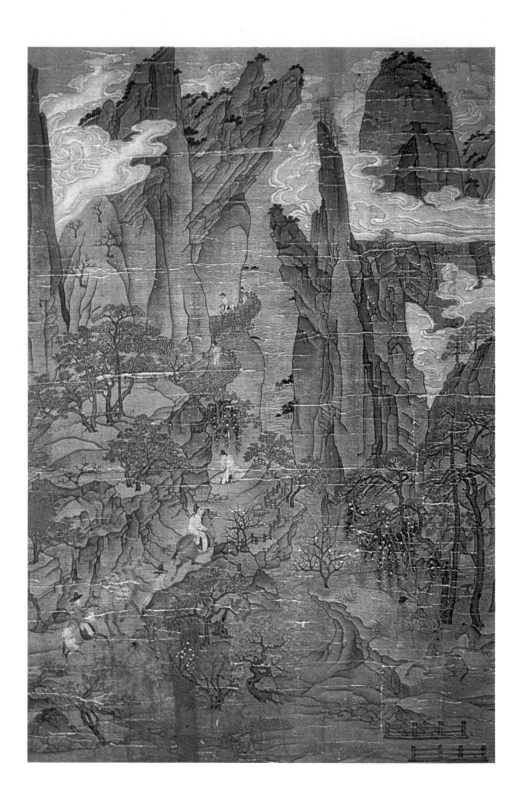

Plate 2. Li Chao-tao (act. ca. 700-30), attributed. *Ming-huang's Journey to Shu*, detail. Eighth-ninth century composition; date of this version uncertain. Hanging scroll, detail. Ink and colors on silk. National Palace Museum, Taipei, Taiwan, Republic of China. (See also fig. 19.)

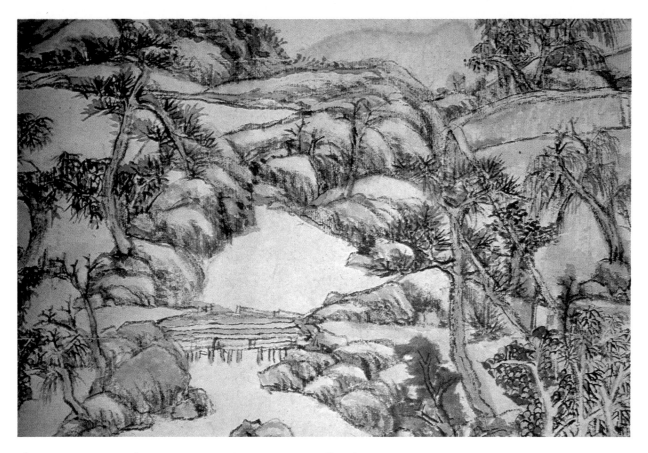

Plate 3. Wang Yüan-ch'i (1642-1715). *The Wang River Villa*, after Wang Wei. Eight century composition; 1711 version. Handscroll, detail. Ink and colors on paper. Metropolitan Museum of Art, Douglas Dillon Gift. (See also fig. 18.)

Plate 4. Anonymous. *Cat and Peonies*. Eleventh-twelfth century. Hanging scroll, detail. Ink and colors on silk. National Palace Museum, Taipei, Taiwan, Republic of China. (See also fig. 22.)

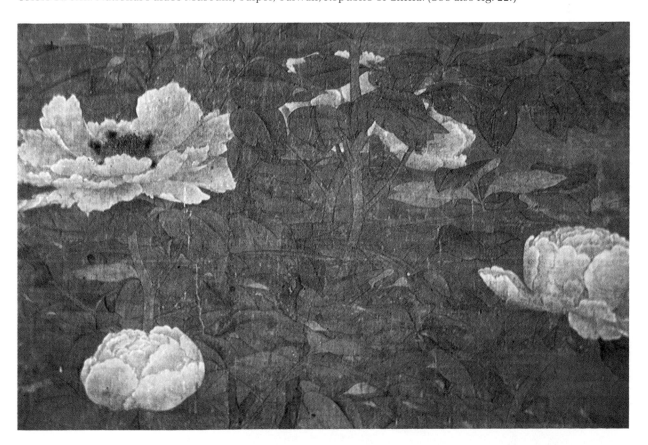

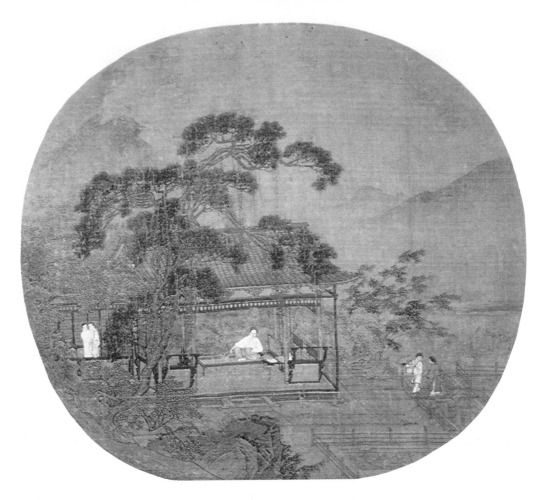

Plate 5. Chao Po-su (1124-84), attributed. *Reading in the Open Pavilion*. Fan painting mounted as an album leaf. Ink and colors on silk. National Palace Museum, Taipei, Taiwan, Republic of China. (See also fig. 23.)

Plate 6. Tao-chi (1641-before 1720). *Man in a Hut*. Album leaf. Ink and colors on paper. Collection of C. C. Wang, New York. (See also fig. 34.)

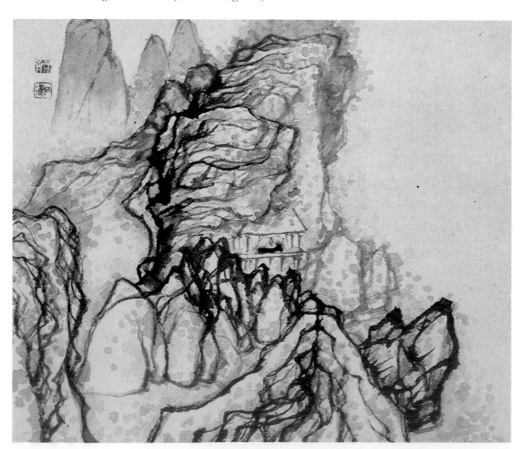

disheveled hair," while works by the other, combining moist ink and open tracts of smooth white paper, were said to be like "icy flesh and jade bones" (cf. figs. 31, 33).[14] Many artists chose to emphasize textures, to make them a focal element of their style. Their emphasis is most apparent in cases of unusually wet ink, exaggerating the texture of the ink itself (fig. 29), and in cases of unusually dry ink, accentuating the texture of the painting surface and of the brush hairs (fig. 32).

The eighth century was the first great age of experimentation with texture, conducted by such men as the Taoist Wang Mo, or "Ink" Wang, who pioneered the splashed-ink tradition. A nearly contemporary text wrote, "When he was sufficiently drunk, [Wang] would spatter the ink onto the painting surface. Then, laughing and singing all the while, he would stamp on it with his feet and smear it with his hands, besides swashing and sweeping it with the brush."[15] Wang's contemporary, a Master Ku, used to pour his ink over the painting then cover it with a cloth, having someone sit on it while he pulled it around and around. Only afterwards was brushwork used to draw the pools into naturalistic shapes and to add detail (cf. fig. 29). Wang Mo also explored the texture of his own hair, still attached to his head, while others left traces of finely split bamboo, reeds, or sugar cane husks, rubbed ink onto the paper with cloth (fig. 28c) or with their hands, and splattered it on through a screen or with the brush (fig. 28d). The type of figure painting handed down by such artists can be seen in a later work depicting a Ch'an Buddhist patriarch, Feng Kan, sleeping with a tiger, done in a style which emphasizes both wet (fig. 20a, b, d) and dry textures (fig. 20e). The wet interior of the monk's robe was created by an ink wash whose liberal application has resulted in irregular pooling and fusing of wet, varied tones. The dark outlines of the priest's robe were also produced by wet ink, which was sufficient to cover the track of the brush and to leave firm outlines; however, the artist used a large, very coarse brush, possibly made of reeds or cane rather than animal hair, leaving a broadly-streaked texture. A different effect is seen in the tiger's fur, where a scratchy texture has been created by short, dry, stippling strokes, probably applied with a rough, worn-out brush.

The use of the wet ink process was historically associated with a libertarian outlay of energy and spontaneous emotion (figs. 20, 29), and was favored by several of China's better-known "mad" artists. In contrast, the dry brush technique, popular since the fourteenth century, most often came out of a context of emotional and intellectual refinement, ethical purification, and social elitism. Deriding practitioners of the splashed-ink manner as "ink hogs," the exponents of dry brushwork were said to have "treasured their ink like gold." Most famous of the latter was Ni Tsan, for whom cleanliness was a passion, whether expressed in his ethical puritanism or in his habits of incessant hand-washing, washing down his studio after visitors left, and, according to legend, washing the trees in his garden. In painting (fig. 32), Ni applied mostly dry brushwork and very little of it, so that his works are as much a study in paper and ink texture as they are in refined brushwork. In his dry brush technique, there is too little ink in the brush to flow readily or to cover the brush track completely, so the brush must be held at an angle to expose it fully; it is literally wiped against the paper in order to transmit the ink. The result is a coarse, grainy effect, produced by numerous small flecks of ink caught against the uppermost texture of the paper. This effect is magnified if the paper is not heavily sized. The black brushstrokes are broken up by the intrusion of exposed white paper into their midst, and they have no distinct contours. The traces left by individual brush movements lose their clarity and are hard to discern, fusing into pale, blurred, ethereal forms.

In later Chinese painting, with its emphasis on calligraphic brushwork, the presence

of rich and varied textures more than compensated for the absence of color. Perhaps the first artist to take full advantage of this possibility was a friend of Ni Tsan's, Wang Meng, famed for the dense texture of his paintings (fig. 31), which achieved extraordinary textural effects not merely through isolated extremes of wet or dry but through the kaleidoscopic combination of all the textural and tonal possibilities. Unfortunately, none of the aesthetic virtues of Chinese painting is harder to capture photographically than its texture, and Wang Meng's painting is a good example of a type which may appear unimpressive, even ugly, in reproduction but which on personal inspection provides a dazzling display of the artist's materials and technical versatility.

Composition:
The Art of Illusion

Composition is the creation, through line and wash, color and texture, of individual motifs of varying shapes and sizes, and the arrangement of these motifs into an overall compositional design. While the artistic or aesthetic value of any composition rests in large part on the abstract play of shapes and colors upon its two-dimensional surface, no purely abstract painting, free of representational concerns, ever appeared in traditional China. Beginning with the very first texts on painting, we may read of the emphasis artists placed on painting according to naturalistic principles, on capturing the illusion of real nature.

The earliest philosophical treatise on landscape painting was written in the early fifth century by Tsung Ping, an aging painter who was no longer able to roam real landscapes in spiritual communion with nature, and thus had turned to covering the walls of his room with illusionistic scenes of the sacred mountains of China. Tsung wrote that paintings could truly serve as substitutes for real nature and call forth an equally sympathetic response from the viewer, if well done. He insisted that neither the smallness in scale, nor the necessary generalization in details of a painting, should detract from its ability to embody the same spiritual vitality lodged in real landscapes. The painter need only worry about a lack of skill in capturing a good formal likeness of nature.[1] In paintings, as in real landscapes, natural or naturalistic forms were an embodiment of sacred principles and a source of spiritual delight. A few years after Tsung Ping, the figure painter Hsieh Ho composed his time-honored "Six Canons" of painting, the earliest enumeration of criteria for evaluating works of art. Hsieh's first and overriding requirement was more aesthetic than formal: he demanded that the artist grasp, in painting, the same rhythmic vitality that animates living subject matter. Other criteriá, more mundane and formal, followed; he demanded that painting truly adhere to the principles of nature: "Fidelity to the object in portraying form," "Conformity to kind in applying colors," and "Proper planning in placing of elements."[2] However metaphysical their ultimate concerns, artists like Tsung and Hsieh believed that spirit was lodged in natural form and could only be grasped through an understanding of natural principles. As Ch'ao Pu-chih later wrote, "Although painting depicts [ideal] forms beyond [the physical forms of] objects, still it is essential that the forms of these objects not be altered."[3]

As any historical survey will show, the ability to capture a naturalistic image in art took many centuries to mature. The early history of painting was marked by the steady but slow development and refinement of those devices by which the artist could transcend the limited scale and inherent flatness of the painting surface. Not until the Sung, some six hundred years after Tsung Ping, could artists like Kuo Hsi (fig. 21) create landscape scenes that we might agree were real enough to "ramble through or dwell in," and which admiring critics described as "just like being there." No sooner had Chinese painters mastered the art of illusion than they began, as a group, to redirect

their primary aims toward greater abstraction and personal expression uninhibited by form (figs. 32, 34). This basic shift roughly divides Chinese painting into earlier and later periods, Shang through Sung, Yüan through Ch'ing.

Plasticity and Organic Form

The simplest representational motif may be created by nothing more than a single continuous outline that entirely encloses the figure, or by a color contrast that isolates it from the surrounding environment (figs. 9, 10e, 11). Defined by its outer edges only, it needs no indication of interior surface characteristics, texture, color, or rounded form. The figure of a shaman which decorates the side of a Shang ceremonial bronze drum (fig. 9), ca. 1200 B.C., is essentially such an image, the outline of his body easily read against the lighter background of dense spirals (incised in the bronze drum, white in the rubbing). The outline of the figure is extremely simple, composed mostly of straight lines with slightly rounded corners. The subtle shape and proportions of the human figure are reduced to common geometrical shapes—a triangular torso, flat rectangular limbs, a cylindrical neck, an ovoid head, and squared spiral horns. All of these parts are attached in an additive manner, juxtaposed head over neck over shoulders, rather than interlocking in a truly composite arrangement. As a heraldic design, the shaman cuts a dramatic figure; but as a naturalistic representation, it is merely an historical point of beginning, a primitive silhouette that does not yet challenge the two-dimensional limitations of the compositional plane (except for the cheek, nose, and eyes, which are raised sculpturally above the bronze surface rather than illusionistically drawn). This figure might be described as ideational rather than naturalistic or organic, and with little change, it could be transformed into the calligraphic conventions of its time (cf. fig. 3).

A similarly posed figure may be found near the bottom of a recently excavated painting (fig. 10), a funeral banner from about 165 B.C., one of the oldest Chinese paintings in existence.[4] The work is something of a cosmic diagram, depicting at the top of the banner the ascent to Heaven (fig. 10a) of a deceased woman (fig. 10b, i) (a petty aristocrat, the Marquesse of Tai, in whose tomb it was found), a scene of the netherworld (fig. 10d) at the bottom, and a funeral taking place on earth in the middle (fig. 10c). The figure we are concerned with here (pl. 1, fig. 10m) is a demigod of the underworld, shown supporting the weight of the earth. Almost one thousand years and a period of tremendous development in naturalism separates this figure from the Shang bronze shaman, although few other works survive from the interim to indicate the stages of progress. In this later example, flatness has been turned into fatness or, in more formal terms, into "plasticity" or "mass," and abstract geometric shapes, additively combined, have given way to more subtle, complex shapes joined in a more organic manner. Although the general outlines are still easy to read, they are treated in a conceptually different manner. A telling detail illustrates this treatment: the line of the right forearm continues past the line of the bicep (fig. 10r), interrupting it rather than joining it at the curve. This simple break in the outline creates the appearance of overlapping planes, forearm in front of bicep, and thus of spatial illusion. More obviously, this illusionism is carried out where the massive head overlaps the chest. Elsewhere, the break in the outline and the overlapping of parts is effectively suggested by a more complex contour. In the head, for example, four separate curves are conjoined to give the feeling of composite

parts; the skull, cheeks, and jaw are structurally integrated and project out into space from a central core. The figure is still schematic, rather than subtly irregular as things are in nature, but one need only look back briefly to realize how far removed it is conceptually from the simple geometric design of the Shang bronze shaman.

No less remarkable about this underworld figure is its embodiment, at an early date, of two basic structural principles: diagonal recession and foreshortening. Most of us know that an object such as a tree branch, when seen from the side, will project horizontally across our field of vision with its full length apparent to us, but as it is rotated in space it will seem to project backwards along a diagonal (rising as it recedes, if seen from above, descending if seen from below). The more it is rotated into depth, the

steeper its diagonal pitch and the shorter its apparent left to right extension: In

the Shang figure, the proportions are adjusted to decorative rather than naturalistic purposes, attempting to fill all the space available, to the point of adding double-jointed knees. But in the early Han banner painting, the underworld figure is adjusted to the dynamics of naturalistic vision. His forearms are considerably longer than his biceps, which might seem ridiculous to us if we did not readily and intuitively interpret them as being foreshortened, his arms angling forward from the shoulders. His legs, too, project forward from hip to knee and are greatly shortened in length compared to the distance from knee to foot. The diagonal placement of the feet completes the parallel. Elsewhere, the diagonal lines of the sides of his jaw, the corners of his mouth, and his eyes all subtly and knowingly suggest naturalistic form and projection in space.

The creation of overlapping and organically related parts, and the suggestion of diagonal recession through foreshortening, were accomplished in Chinese painting primarily by linear drawing. In the depiction of Priest Pien-ts'ai (fig. 12), one sees these basic principles of naturalistic composition raised to the highest level found in Chinese figure painting. The artist's careful observation of human form is displayed in such details as the overlapping of the left nostril by the ridge of the nose, and in the highly organic design of the mouth, an effectively structured cavity between the cheeks and jaw, enclosing teeth and tongue. Face, cheeks, and skull merge organically into a cubical head, with the brow and mouth diagonally placed and subtly foreshortened. In spatially sophisticated works like *Cat and Peonies* (fig. 22), the radical foreshortening of leaves and flowers contributes to the feeling that we can almost reach out and touch them. And even in such a rough and seemingly abstract work as the *Buddhist Patriarch and Tiger* (fig. 20c), the head of the priest reveals a fundamental understanding of foreshortened construction, part of an artistic heritage not readily abandoned or forgotten, even by those beyond rules. Once mastered, the techniques of overlapping parts, diagonal recession, and foreshortening all became a standard part of the Chinese painter's vocabulary, although they were practiced empirically with none of the mathematical accuracy found in Western studies of foreshortening.

Another major factor contributing to the contrast between abstract and naturalistic figures may be seen in the comparison of a Han dragon, shown rising up the side of the funeral banner of Lady Tai (fig. 10g), with a sophisticated Sung relative, painted some 1400 years later and seen peering out of a darkened grotto (fig. 28). The Han dragon, while painted in color, is none the more naturalistic for it. The application of color is "flat" or unmodulated, giving no sense of three-dimensional form or rounded contours, projection or recession. The Sung dragon, on the other hand, although painted in ink,

displays the basic contribution of color—or more specifically, of tonality—to structure: lighter tones seem to project outward, darker tones to recede. A wash of dark ink is tucked behind the Sung dragon's raised left leg to provide a sense of the curved recess between it and the belly (fig. 28a). More effective is the use of a darkened ink wash along the dragon's nose ridge, behind his nostrils and across his brow (fig. 28b). The areas left white, the eyes, cheek bones, and nostrils, all seem to swell dramatically from these darkened recesses. If we look carefully at this playful beast, we see that although tonal modeling is somewhat schematically applied, indicating no single consistent light source as one might find in European painting, it certainly creates a sense of surface irregularity and plastic form that is lacking in the flat and basically decorative Han dragon.

Elsewhere in the Han funeral banner, however, we may observe the surprisingly early date at which such tonal variation was first used to create plasticity. A detail of the work—a ritual jade object called a *pi*, which symbolizes the disc of Heaven (pl. 1, fig. 10j)—illustrates this point. It is decorated with a pattern of raised nibs, known as the "grain pattern," which can still be seen today on museum pieces. Remarkable, given the antiquity of the work, is the way in which the artist has "raised" the nibs by painting them white and setting them against a darker, cream-colored background. Without using line, and relying only on tonal variation, the artist has achieved the illusion of solidity. More than a thousand years later, *Cat and Peonies* (pl. 4, fig. 22) marked the peak of sophistication in the Chinese use of tonality to help model organic forms. To begin with, the artist juxtaposed darker (fig. 22b) and lighter layers (fig. 22c) of malachite pigment in order to contrast the upper and lower sides of the radically foreshortened leaves. In addition, he sometimes placed a wash of blue-green malachite along the central axis of the leaves to create a sense of recessed curvature along the fold (fig. 22d). Finally, he carefully modulated the transparency of his white petals, increasingly diluting the pigment toward the center of each one so that they seem to emerge from the brown of the silk and to project from the core of the flower (fig. 22a).

In Chinese painting, the role of color in adding naturalistic surface definition was largely usurped by described surface textures, traditionally done in ink and, for the most part, with linear brushwork. Described texture—as distinguished from the texture of brush, ink, and ground—is composed of gathered brushstrokes that depict the play of light and shadow across the surface of a motif and define its regular, small-scale surface character. Early examples of linear texturing are found in the scales of the fish on the Shang bronze drum (fig. 9) and the Han dragon's scales (fig. 10o), each line describing a shadowy recess, although in these cases they still create a sense of decorative patterning more than one of real texture. More naturalistic in texture is the Sung dragon (fig. 28), where a broad, irregular lineament seems to describe thick, ruggedly armoured plating, complementing the solid linear structure and tonal modeling of the creature. A remarkable early example using colored wash to create a sense of texture may be found in the Han funeral banner (pl. 1, fig. 10k), where the artist has placed a golden-brown wash at regular intervals over a decorated silk canopy to suggest the smooth, reflective sheen of its silken surface. Varied and specialized textures were the hallmark of any highly naturalistic painting; in *Hsiao I*, for example, we have looked at the linear, twisting strokes used to describe the matted texture of Pien-ts'ai's thatch seat (fig. 12e) and the ragged-edged strokes used to describe its rude wooden arms (fig. 12b). We should also note the small, stippling strokes used to depict the texture of the priest's closely-shaven beard and tonsured skull.

It was in landscape painting, where they described the regular surface character of

rocks and of mountains seen from afar that texture strokes, or *ts'un-fa,* were given the greatest attention. What we think of loosely as "schools" of landscape painting each retained a certain conventionalized type of texture stroke as part of its stylistic identity, and major masters within each school established their personal variations of these strokes. Although in later times these landscape texture strokes came more and more to be treated as an abstractly expressive feature and functioned as a stylistic signature of the artist, each type had its origin in regional geography. The so-called "curled-cloud" texture stroke associated with the name of Kuo Hsi (fig. 21) has already been described in detail (pp. 27-28). Kuo Hsi also added to his soft, earthen landscapes irregular patches of ink known as "devil's face" texture strokes (fig. 21b). Kuo's style is remarkably accurate in its description of the unusual, dry landscape of much of northwest and north-central China, a region covered with a layer of dust-deposit known as loess, which in some places accumulates to a depth of 250 feet. The mountains described by Kuo Hsi are really what remains after rivers, wind, and frequent earthquakes helped carve deep gullies into this easily eroded soil, the highest ridges standing at what was originally ground level. Smoothly textured and softly rounded, these mountains of dust often do look like clouds, and Kuo Hsi's smoothly disturbed wash, darkly etched fissures, and deeply pitted "devil's faces" are less artistic fantasy than an inspired response to nature's own art.

Several other common types of texture strokes comprise an essential part of the Chinese landscape painting vocabulary. Most enduring throughout the centuries was the so-called "hemp-fiber" texture stroke first developed in the tenth century by Tung Yüan, who used long, curved, perhaps slightly twisting strokes of the brush to describe the rippled surface of softly rounded, grassy hills in south-central China, along the lower Yangtze River. Unfortunately, no original Tung Yüan painting survives, but his style is reflected in the works of his many Yüan, Ming, and Ch'ing followers, most of whom came from this region (figs. 30, 31). A harder, more angular texture type, describing a large-scale fracturing pattern, was known as the "axe-cut" texture stroke. This stroke was used to describe the low, dramatically fissured granite hills of the Hangchow district and the south China coast. To produce the "axe-cut" texture stroke, the artist placed the brush on edge and swept sideways, a technique that falls somewhere in between brushline and area wash and seems to combine the two in one. It was primarily associated with professional artists of the Southern Sung imperial painting academy, especially Li T'ang, who originated the type with small, meticulous strokes, and Ma Yüan and Hsia Kuei, who later handled it more broadly and suggestively. Several variants are illustrated here, both the "small axe-cut" (fig. 28e) and the "large axe-cut" (figs. 23e, 26e, 27a). Each of these texture strokes was developed in the Five Dynasties and Sung period, the peak of naturalism in the history of Chinese painting, and they formed the basis of much of the increasingly abstract and calligraphic brushwork of later Chinese painting.[5]

Linear and Atmospheric Perspective

The plasticity of a figure suggests a spatial environment in which that figure might turn and move about. Perspective, literally meaning "to look through," refers to a variety of techniques used to develop and sustain that larger spatial environment so that we seem to look through nearer things toward others farther away. Chinese painting, especially

figure painting, often implied rather than depicted its spatial environment, surrounding its major figures with broad expanses of unpainted silk (figs. 12, 15). Nevertheless, this art of implication was made plausible by the use of basic perspective principles, some of which had been developed at quite an early date, as shown by the recently-discovered Han funeral banner (fig. 10). Two general aspects of perspective may be distinguished: linear perspective, based on placement and proportions, and atmospheric perspective, which depends on adjustments in color (especially tonality) and clarity.

The three basic ingredients of linear perspective used by Chinese artists include overlapping placement and adjustments in both the elevation and proportions of objects according to their apparent distance. The lack of overlapping of the several figures on the Shang bronze (fig. 9) and of the larger figures on the Han funeral banner (fig. 10), all distributed evenly over the available surface area, is a major component of the decorative character of these works. However, in the smaller enclosed scenes of the banner painting (pl. 1, figs. 10b, c), a more natural order prevails. In the center of the painting we find a depiction of Lady Tai herself, leaning on a wooden cane (an autopsy of her perfectly preserved corpse showed she had suffered a broken hip; her cane was preserved in her tomb); behind her stand three female servants, each one overlapping the next and generating a sense of depth in the scene. This simple principle is used to even greater effect below, in the funeral scene, where the participants not only overlap each other but are themselves dramatically set behind five great ceremonial vessels of bronze and lacquer. A spatially inconsistent detail occurs on the right side of the scene, where the robe of the more distant figure is draped over the bronze vessel in the foreground (fig. 10l).

A second rule of thumb in linear perspective is that, in arranging figures, "up is back." This is a natural outgrowth of the principles of diagonal recession in which, as we have already observed (p. 33), an arrangement in depth when seen from above seems to proceed from lower down to higher up. This rule was applied to the funeral scene of the Han banner (fig. 10c): in the background, ceremonial vessels are placed on the surface of an altar or casket which seems suspended in mid-air, but which is clearly intended to stand farther back in the scene, fully grounded on four, small black legs. Ground lines, ground planes, and points of view established in the structure of a painting depend upon this principle of spatial recession. In the scene above (fig. 10b), the overlapping of Lady Tai's servants suggests a sense of depth, but since all of the figures stand firmly on the same base line, we seem to view the scene from ground level, the ground plane on which they stand not exposed because of our low point of view. In the funeral scene, however, the unpainted space between the foreground and the raised altar must be understood as a rising ground plane, seen from a slightly elevated point of view.

These factors are related to one more basic principle: the larger an object, the closer it seems to the viewer. This principle was clearly understood in the funeral scene of the Han banner, where the large foreground ceremonial vessels contrast greatly in scale with the smaller ones in the background. However obvious this naturalistic principle, it was sometimes superceded in Chinese painting by social principles, as in the above scene where Lady Tai was drawn proportionately larger than any of her servants, although it is known that she stood but five feet tall. Here the natural proportions of these figures have given way to ones reflecting their relative social status.

While the funeral banner of Lady Tai demonstrates that all of these cardinal princi-

ples were introduced at an early date into the Chinese painting tradition, the attempt to apply them consistently and to extend them to the large-scale setting of landscapes was only achieved through a series of gradual improvements in naturalistic rendering. Establishing a consistent ground plane and point of view was a difficult technical accomplishment, not attained until the mid-to-late Sung period and rarely seen after the mid-Yüan. Inconsistent ground planes and multiple points of view were the rule rather than the exception in Chinese landscape painting, and to regard this merely as a flaw is to miss its positive contribution to the art. Take, for example, the painting, *Ming-huang's Journey to Shu* (pl. 2, fig. 19), anonymous, undated, perhaps mistitled, but probably reflecting a mid-eighth to early-ninth century conception.[6] In this early monumental landscape painting, most of the human activity is spread across a stage-like foreground divided by flowing water into three smaller staging units, right, center, and left, which are linked by two bridges. Set behind this foreground is a middle ground area of rocky, precipitous mountains, also divided into three sections. Down the chasms to the right and left of the central cluster of peaks are penetrating views into a background of water and remote shorelines. Rather than attempting to present in this landscape only what can be seen from a fixed point of view—that is, a single scene—the artist has introduced varying points of view in order to create a panoramic vision of nature. Although the painting is but twenty-one inches high, the artist has invited us, by multiple perspectives, to move our head left and right, to peer down and crane up, to experience nature as diverse and unlimited. The foreground is seen from above, the ground plane fully exposed in order to provide ample room for, and a clear view of, the activity. The mountains are set in the middle ground, and the pine trees growing in their middle reaches are scaled down from those in the foreground. At this elevation, the ground plane from which many of these trees rise has been foreshortened, reduced to a base line so that we seem to view them from the side rather than from above (fig. 19j); those areas where a rising ground plane is still visible seem artificially or awkwardly tipped forward (fig. 19c). In the uppermost reaches, the undersides of these rocky cliffs are exposed, and in many cases even the lower trunks of the trees (which are still further reduced in scale) are hidden (fig. 19d), revealing only their upper growth and providing the viewer with the sense of gazing upwards toward them from below. The background water and distant shorelines (fig. 19k, a) are seen from above, in the cosmic (or so-called "bird's eye") view common to Chinese monumental landscape painting.

 This multiple viewpoint is an artistic vision, not what the eye can take in all at once. Its spatial inconsistency becomes especially apparent at certain points where the artist has had to seam together his disparate scenes. At one point in the painting (fig. 19h), within a few inches of space, we find ourselves looking at lofty mountains from below and distant shorelines from high above. Just below this (fig. 19l), we find foreground and background trees closely juxtaposed, which would occur naturally only if they were brought together by a low ground plane and a level point of view (cf. fig. 27), but the fore- and background planes are both artificially tipped up and seen from above. This inconsistency could perhaps be rectified if we understood the watery background somehow to be set far below the foreground, behind some precipitous dropoff. But on the left side (fig. 19m), we can see that the flow of water from the far distance into the foreground is continuous, and as if realizing that his naturalistic talents were here being stretched, the artist has masked this point with trees, while a thick bank of clouds serves the same function on the right (fig. 19b). However strange to foreign eyes, this type of changing viewpoint seemed in accord with natural principles to many Chinese

artists and not a violation of it, and it is an essential part of many of the great monumental landscape masterpieces, like Kuo Hsi's *Early Spring* (fig. 21), from the Northern Sung period.

A unified perspective, one that seems more natural to the Western eye, was achieved in works of the Southern Sung period, in which, characteristically, the cosmic, bird's-eye view was abandoned in favor of a lower, more intimate point of view. In Ma Lin's *Fragrant Springtime, Clearing After Rain* (fig. 27), the epitome of Chinese landscape naturalism, a small rain-swollen stream flows out of the background, twisting back and forth over a low, foreshortened ground plane, and expanding rapidly in scale as it arrives at the foreground confluence of several rivulets. In part, the diagonal arrangement of the zig-zag stream establishes the low, consistent ground plane, the horizontal stretch of each section far outdistancing its vertical rise; in part, the accurate proportions of the natural motifs create this effect, the stream and the trees adjusted in scale to their apparent distance; and in part, the spatial relation between the foreground and distant trees creates it, the relative position of their bases (fig. 27g, d) in accord with the notion that for objects seen from above, "up is back." Expanding upon this notion, the placement of the tree tops (fig. 27f, c) observes the converse principle that for objects seen from below, "down is back." If one imagines lines drawn from top to top (fig. 27f, c) and bottom to bottom (fig. 27g, d) between nearby and distant trees, the lines quite clearly converge in the distance to form a naturalistic horizon line. In a painting like this, one is readily able to sense the literal meaning of perspective, or "looking through."

The empirical character of the Chinese observation of nature should again be stressed, and in architectural drawing, where one might expect parallel lines to converge with distance, they most commonly diverge or else continue running parallel despite changes in depth. Examples of this may be found in the various "parallel" lines of Chao Po-su's *Reading in the Open Pavilion* (fig. 23i) and in the bamboo table (fig. 12f) beside which Hsiao I's attendants are preparing treats. An adequate explanation for this phenomenon is difficult to provide, but the attitude which became prevalent among landscape painters within a few short generations after Ma Lin was that his accomplishment of a unified perspective represented only a narrow point of view, that an artist should not *be limited* by his eye.[7] For such later Chinese painters as Ni Tsan (fig. 32), abstract, expressive principles governed their art, not naturalistic ones.

Before turning to these abstract principles, we should complete this discussion of naturalistic composition by shifting our attention from linear to atmospheric (or aerial) perspective. Atmospheric perspective includes the related phenomena that receding objects grow pale, exhibit reduced contrast in tone and saturation, and become increasingly less distinct in their details. Although Chinese artists never observed the principle with regard to color saturation, Kuo Hsi expressed something of their awareness of the other aspects of these phenomena when he wrote, "The effect of distance is obtained by the use of misty lines which gradually disappear. . . . A distant mountain has no texture; distant water has no waves; a man at a distance has no eyes. Not that they have none, but that they seem to have none."[8] These atmospheric features may be found in Kuo's own work (fig. 21), as well as in Ma Lin's *Fragrant Springtime*, where the distant trees (fig. 27c) have been reduced to pale washes of ink and shrouded in mist, their individual leaves and branches scarcely apparent, even though the general form of the tree is retained. Such richly atmospheric effects are the hallmark of Sung naturalism, rarely matched or even attempted in later periods.

At this juncture, let us turn toward a consideration of abstract composition by noting

first that while illusion and abstraction represent essentially contrasting aspects of Chinese painting, they are nevertheless intimately related and are both present in varying proportions in any given work. For an artist to work according to "his own" principles did not mean that he entirely abandoned those of nature. Rather, in the context of Chinese representational painting, he edited and modified nature to express his own feelings and intentions. An example of this may be found in the application of atmospheric perspective in a sixteenth-century album leaf by Shen Chou, entitled *Return from a Thousand Leagues* (fig. 33). The artist was a notable stay-at-home, rejecting public fame in order to tend his own garden, and the poem inscribed on the painting describes nostalgically an autumn homecoming:

> The red of autumn comes to river trees
> The mountain smokes freeze fast the purple evening
> Those who long for home
> Return from a thousand leagues.[9]

The painting portrays the village to which the artist returns, a cluster of cottages along the banks of an inlet or river that opens out to the left. In counterpoint to the three other boats heading out from land, one small boat (fig. 33b), presumably the artist's, has just set ashore in the foreground. The tree to the right of the boat bends low to receive the artist seated beneath it (fig. 33a), as if mimicking the posture of the two servants unloading his boat. A large promontory at the right of the painting leans out over the bay, offering a special place from which to hail a returning friend, or perhaps offering its own welcome. These personified attitudes taken on by natural motifs bring us to the point where naturalism blends into abstract expression. Abstractly expressive, too, is the cool expanse of watery distance on the left and the warm embrace of home on the right. Both expressive and naturalistic is the artist's adaptation of atmospheric perspective principles, which heightens the sense of arrival by treating the left side of the painting along both banks of water as distance, accompanied by the loss of clarity and muting of tones, while the returning voyager is welcomed into an area on the right of greater detail and lively, contrasting tones. Front and back have been replaced by a right-left relationship in the mind of the artist, and illusionistic principles adapted to express the artist's subjective view.

Composition:
The Art of Abstraction

In pursuit of naturalism, early Chinese painters developed considerable skill in creating the illusion of organic shapes and three-dimensional space, in suggesting naturalistic textures and, for those who wished to, in modeling with naturalistic colors. Of course, standards of illusion are relative and what seemed realistic in the fourth century was already dismissed in the ninth as primitive; but early critics wrote of painted dragons so real that they flew off the walls of temples, of precipitous waterfalls that gave the viewer a chill in the midst of summer, and of landscapes that one could dwell in or ramble through as if one were really there. After the thirteenth century, most Chinese painters, led by the scholar-amateurs, turned away from this naturalistic mode, denigrating subject matter as nothing more than a vehicle by which the artist might express his mood, reveal his personality, and cultivate his spiritual refinement. Yet any painting, however successful its illusionistic devices and naturalistic effects, remains a two-dimensional collection of lines and washes, colors and textures, and an abstract arrangement of shapes and sizes. This fact may be emphasized by the artist in creating the work, or by the viewer in observing it.

In naturalistic art, shapes and sizes are adjusted to organic proportions and to the way the eye sees through objects from near to far, according to nature's own peculiarities. In the art of abstraction, in its purest form, the artist is no longer concerned with natural subject matter but with art itself, and with self-expression. Shapes and sizes are regulated according to artistic taste and inner vision, according to aesthetically satisfying designs and personally expressive rhythms. The elements of painting are exalted rather than disguised. Traditional Chinese painting, however, was never purely abstract. Although it tended increasingly toward abstraction after the Sung, a basis in representation was always retained. Naturalistic illusion and surface abstraction were always present together, blended in varying degrees and proportions.

Abstraction was an important factor in the minds of Chinese painters, both in the realm of aesthetics, where it was nourished by deeply rooted cultural values, and in the realm of style, where it was expressed through certain basic patterns of artistic behavior. We will discuss six general components of stylistic abstraction: abstract shapes; the expressive role of line, wash, color, and texture, independent of their descriptive function; patternization, or the repetition of a vocabulary of basic shapes; voids; the primary compositional design of a painting; and the dynamic interaction of the parts of a painting. But first, let us note the conceptual attitudes toward abstraction that helped shape Chinese painting.

The role of abstraction in Chinese aesthetics stemmed from the concept of the Tao, the single most fundamental Chinese concept. The Tao, like the Judaeo-Christian-Islamic concept of a single God, represented a metaphysical and cosmological ultimate, and the Chinese Tao was the ultimate in abstraction. The Chinese thought of it as that source which gives life and form to all material beings, yet which itself is utterly inac-

tive and immaterial, undifferentiated and therefore beyond description. The behavior of the Tao is the most profound of mysteries, but it was said to give rise to *yin* and *yang*, the principles of basic complementarity, or of primary distinction, which in turn combine to generate all of the patterns and endless variations of nature. Not capable of being understood independently but only in relation to each other, *yang* represents the principle of active generation and *yin* the principle of receptive nourishment. *Yang* is expressed as the sun, as warm and dry, as mountain and male; *yin* is expressed as earth, as cool and moist, as water or valley, and female. The Tao is obscured by all the variety, by all the detail it engenders. Thus, the Chinese artist often sought lifelikeness not by amassing detail, but by tracing forms back to their vital source in the abstract, generative principles of *yang* and *yin*, by reducing forms to their essence and eliminating or minimizing such extraneous details as color, and by expressing in heightened, abstract rhythms the vitality that the Tao imparts to nature.

For the Chinese, the ultimate truths were usually to be found in the abstract and immaterial. When, from Shang times on, the Chinese emperor sought the advice of Heaven or of his deified ancestors, he generally received a response conjured by a court diviner in the form of plain, abstract cracks on oracle bones or sea-tortoise shells, simple lines which only the diviner could read. Similarly, it was often said that both Chinese painting and calligraphy had their origin not in human invention but in the abstractly expressed language of Heaven, sent down to earth for the purpose of civilizing humankind and manifest in the form of simple, abstract linear patterns. Varying legends exist describing this primordial event: according to one, these linear designs or diagrams were borne by a divine sea-tortoise that emerged from the Lo River, while another attributed their conveyance to a "dragon-horse" which rose from the Yellow River.[1] From here, humans took over by creating calligraphy and painting. The written forms developed from these simple lines remained abstract, but were made more complex to express the sophisticated conceptual nature of human language; painting transformed these abstract patterns into concrete representations of the natural world as seen by the eye. Calligraphy, the more abstract of these two offspring, was generally held by critics and connoisseurs to be China's foremost visual art form and was a constant source of inspiration and learning for the painter. Let us briefly note some of the compositional principles that distinguish the basic script types, to round out our earlier discussion of calligraphic line and to prepare the way for a discussion of abstraction in painting.

Abstract Shapes (in Calligraphy and Painting)

We have already compared the different calligraphic scripts—seal, clerical, regular, and cursive—in terms of individual brushstrokes and their dynamics. These script types also differ by virtue of certain regular principles which determine the way in which strokes are combined and arranged to form characters (each character representing one complete Chinese word) and the way in which characters relate to each other. If, for example, one draws imaginary boxes around the characters written in seal script (fig. 3a), most will be proportionately tall. This vertical elongation of the entire character combines with the essential thinness of line to give the seal script a light, lean, wiry appearance. In clerical script (fig. 4), on the other hand, it is the horizontal strokes that are emphasized and the short vertical lines that are secondary. The strokes most heav-

ily modulated are horizontal, especially those at the very base of the character (fig. 4e), or downward diagonals at the conclusion of the character (fig. 4h). The emphasis in clerical script is on forceful brushwork and massive shapes. To stabilize the weight of these shapes, the heaviest strokes are set low in the character, and the general proportions of most characters, in keeping with these other features, are those of a squat, horizontal rectangle (fig. 4f). It is as if the weight of the individual strokes helped determine the proportions of the complete composition. In both of these scripts, the characters are evenly arranged on a rigid grid of vertical columns and horizontal rows. The distance between each character is formally regulated and each character is treated as an independent, isolated composition.

The regular script departs from its predecessor, the clerical script, less in terms of individual brushstrokes than in terms of the arrangement of these strokes. Some of the characters are elongated in height (fig. 5f), others are compressed (fig. 5h), while many more are square in proportions (fig. 5g). The result of this irregularity of height is that unequal numbers of characters appear in each column, liberating the arrangement of words on the page from the inflexibility of an axial framework. The artist is free to stretch words out or to bunch them together, according to rhythmic impulse. In this regard and others, the regular script differs from the earlier scripts, offering greater opportunity for informal variation and artistic spontaneity. If there is one emphasis in the design of each character, it is on the upward slant of the horizontal strokes, rising as they travel from left to right (fig. 5a). In this way, too, the regular script is liberated from a mechanically regular horizontal-vertical axis. This upward movement introduces a light, buoyant feeling into the dynamics of the script, in contrast to the severe and weighty dynamics of the clerical script.

Most informal of all is the cursive script, in which all of the compositional flexibility of the regular script is not only retained but exaggerated. The horizontal lines continue to slant upwards (fig. 7a), while the sizes and shapes of characters and their numbers per line are adjusted at the discretion of the artist. Moreover, in the cursive script the detailed structure of the regular script characters is greatly abbreviated, and the remaining strokes are often linked by rapid, uninterrupted movements of the brush. Compare, as example, the varied forms of the word *shu*, "to write, writing," which in regular

script (fig. 7d) is composed of ten strokes 書; *shu* may be abbreviated into four

strokes, 书, and this may be further simplified by omitting the dot and linking the

remaining strokes into this form: 乬 (figs. 7d, 8f).[2] Sometimes two, even three char-

acters may be joined in a single linear and rhythmic sequence (fig. 8a), however the artist wishes. In the cursive script, the already abstract form of the Chinese written word is made still more abstract. Of course, if writers wished to be read, even their draft script had to follow some basic rules of abbreviation; but the rules granted wide latitude, and many writers, to a lesser or greater degree, favored style over content so that their writing, then as now, was difficult or impossible to read. The student who wishes to deal with abstract shapes can do no better than to concentrate on the varied forms and expressive dynamics of Chinese calligraphy, which range from simple (fig. 5) to complex (fig. 6), from relaxed (fig. 7) to taut (figs. 3, 8) to forceful (fig. 4), from rugged and irregular (fig. 6) to divinely elegant (fig. 5).

In shifting our attention from the abstract shapes found in Chinese calligraphy to

those in Chinese painting, let us return to an earlier comparison between the organic form of the priest Pien-ts'ai (fig. 12) and the less naturalistic and more abstract form of the Shang bronze shaman (fig. 9). In the former, the shapes and proportions are complex and specific. The outline of the left side of the priest's face, for example, combines separate lines for the curve of the skull and that of the brow, for the bony structures of cheek and jaw, and for the soft flesh covering the cavity of the mouth. All of these parts are tightly integrated, as is the structure of the neck and torso. The form of the bronze shaman, by comparison, is simple and additive: the head is a near oval, only slightly adjusted to account for the breadth of skull and the narrowness of jaw; a geometrically regular torso is given the form of a triangle; a cylindrical neck sits on top of the shoulders, rather than growing out of the upper torso. The attenuated body of the bronze shaman is but slightly less abstract than the geometric spirals of the background, of which it is a systematic extension. Exceptionally close to plane geometry, both the lack of artfulness and the early age of this Shang figure help to mark it as "primitive."

Yet the reduction of organic human forms to simple abstractions was by no means limited to early or unsophisticated works of art. Indeed, while naturalistic complexity was appropriate for priests like Pien-ts'ai, traveling merchants (Hsiao I's disguise), servant figures, other members of lower social classes, and in general for historical narratives rather than for idealized portraiture, the more common presentation of the upper-class gentleman (fig. 23f) and especially the gentlewoman (fig. 15) was in the form of abstracted, simplified figures, round-faced and devoid of any great detail or three-dimensionality. The aristocracy, after all, conceived of itself as lofty and pure, liberated from mundane realities, and in harmony with the abstract truths of the Tao. In hieratic Buddhist figure paintings as well, one often finds an array of figures ranging from the abstract, generalized forms of the austere Buddha and his comely, idealized Bodhisattvas (fig. 16), to the more natural forms of priests and early historical followers of the Buddha, to the supernaturally grotesque forms of guardian figures, portrayed with bulging veins and muscles—all, of course, being painted by the same artist or group of artists.

In each of these cases, our comparison has been between a naturalistic form and a simplified, geometrically regularized "primitive" or idealized type. But this is only one type of distortion by which natural subject matter was rendered more artful and abstract. In later Chinese painting, the more consciously abstract phase of Chinese painting history, forms were frequently transformed by complex and irregular lines into shapes that were intentionally awkward and lacking in "form-likeness" (figs. 30-34). This was done to disguise any technical expertise on the part of the avowedly amateur artist, an educated aristocrat who painted only to express and please himself and his literati friends, who shunned the skills of the professional artist and adhered to the tenets of calligraphic brushwork. In contrast to the awesomely naturalistic forms of the Sung period (figs. 21-23), those of Yüan through Ch'ing often seem childlike and naive. The trees and mountains of Shen Chou (fig. 33), for example, seem to be little more than sticks and stones. They lack detailed indications of scale and texture, and they are only loosely defined or suggested by unclear and incomplete outer boundaries. Often, Shen Chou's motifs take on very un-treelike and un-mountainlike postures, playfully imitating or personifying the movement of human beings, the trees bending low, the mountain stretching out to welcome the returning artist. In another leaf from this same album by Shen Chou, a similar, flat-topped mountain seems to lift the artist up to the sky, so that he may brush a poem upon the clouds.[3] Whereas a Sung painting tends to overwhelm the viewer with a tangible vision of nature, the Ming and Ch'ing painting

exults in being a painting, a collection of brushstrokes, an artistic statement. Distortion and incompleteness characterize its abstract forms, generated by independently expressive brushwork.

Independent Role of the Elements

We have seen how, in Chinese calligraphy, a given character may be written in a broad range of styles, varied according to script type, traditional "school" style, and individual manner. In the historical progression from seal to clerical scripts (figs. 3, 4), the role of the flexible brush and the modulation of individual lines first began to complement and aesthetically vie with the seal script's purity of structure. In the cursive script, (figs. 7, 8), the flowing linkage of strokes brought dynamic action even more to the fore, while the simplification of the form of cursive characters further contributed to the abstraction of calligraphic structure. In paintings, too, because Chinese artists often concentrated on execution and limited their range of composition, we find numerous examples of basic themes rendered in varied degrees of abstraction, like written characters executed with varying degrees of cursiveness. Chao Po-su's Sung period fan painting (fig. 23) and Tao-chi's early Ch'ing album leaf (fig. 34) are like varied performances on a given character, sharing in common the time-honored compositional arrangement of a Chinese gentleman who is seated at the center of the painting, as if he were the hub of the universe, surrounded by the artistic environment of his studio, which in turn is seated in the midst of nature. But in execution the two works could hardly be more different. Careful and descriptive, Chao Po-su's *Reading in the Open Pavilion* is drawn with brushwork sometimes analogous to the regular script (fig. 23h), with architectural elements done like unmodulated seal script (fig. 23a). It is a showpiece of descriptive talent. Within its diameter of nine-and-one-quarter inches are such detailed motifs as a pair of hanging scrolls with readable landscape scenes (fig. 23b), each but one-half inch tall, and an open manuscript only one-eighth inch tall with written characters upon it (fig. 23d). The architectural features are an historian's delight. Everywhere in the painting, brushwork is transformed into naturalistic shapes and textures that encourage us to look ever more closely, as if, like nature itself, the painting could expose ever greater detail. The painting is, of course, nothing more than brushwork, but we see that well-disguised brushwork last of all.

In viewing Tao-chi's work (fig. 34), on the other hand, after looking closely in order to decipher its forms, we are likely to pull back again, to see if perhaps a distant view might make it more legible. His brushwork is like cursive script, displaying abbreviation and linkage, eliminating unnecessary detail and emphasizing dynamic rhythm. His colored dots are not part of the mountain but part of the visually dynamic surface of the painting. To capture with lines and dots his heightened state of energy, Tao-chi first moistened the paper and then painted rapidly while it was still wet, forcing lines to bleed and tones to fuse. It has been written that Tao-chi's "movement of line in the drawing of rocks is too grand, too sweeping, to be limited to particular objects, and the use of multiple contours suggests the artist's refusal to fix such limits. Tao-chi is not so much depicting rocks as presenting to our senses the forces that mold and destroy rocks. Experiencing empathically the movements of his hand as it wielded the brush, we take part in an awesome act of creation."[4] Stressing the independently expressive character of line and color, rather than their descriptive potential, Tao-chi ventured as

close to pure abstraction as any traditional Chinese artist dared. Only the familiarity of the theme makes the blotted pigments in the center of the page recognizable as a lofty, white-robed scholar seated behind his black desk, probably representing Tao-chi himself looking out at the world beyond, observing it as a swirl of lines and vibrantly colored dots, an extension of his own abstract, artistic vision.

If these two works represent the extremes of the descriptive and expressive functions of line, two closely related works by Ma Lin (fig. 27) and Hsia Kuei (fig. 26) illustrate the degree to which slight variations or adjustments in the degree of abstraction shape the personality of a painting and are essential to the artistic unity expected of an excellent work of art. We have already looked at the naturalistic structure of Ma Lin's *Fragrant Springtime*, with its knowing application of linear and atmospheric perspective principles. Ma's ink washes, set down darker over lighter, are carefully coordinated to model the specific shapes and textures of weathered rocks and gnarled trees. Although Hsia Kuei also uses axe-cut texture strokes, his brushwork seems less concerned with the details of form and is more suggestive of the natural forces that shear and shatter hard stone. The heightened contrast between the dry traces of long, sweeping brushstrokes (fig. 26e) and the fused tones of wet ink washes (fig. 26c) takes us in the direction of expressive abstraction. While Ma Lin's bamboo leaves are each provided with an outline and then filled with a light green wash, Hsia's (fig. 26i) are done with single quick jabs of the brush, loosely gathered along the stalks and stems. Some of Hsia's brushwork is done with the brush tip intentionally split in two to leave a blurred but visually arousing effect, suggesting bamboo and tree leaves tossed about by the wind. In Hsia Kuei's *Pure and Remote Views*, much more so than in Ma Lin's landscape, we tend to be impressed by line *as brushwork*, by landscape *as art*. The contrast can be overemphasized, for in a larger spectrum of works these two are not so different, but this contrast is significant enough to help differentiate the personalities of these two works. Ma Lin's is a small, intimate album painting, focused closely on a few evocative motifs, concerned with the quiet mood and feel of early spring. The viewer is invited to pause, not only to look at the scene but to smell the fragrance of budding trees and to enjoy the sound of the gurgling brook. Free of dramatic pretensions, no single feature stands out to disturb its careful, aesthetic balance. Hsia Kuei's handscroll, by contrast, leads us on an expansive, adventurous journey, bumping along over mountains, following pathways through narrow defiles, and skimming swiftly over broad stretches of water. It is marked by striking contrasts of tone and scale, by surprising shifts in distance and clarity. Hsia Kuei's rapid, highly energized brushwork and abstracted, swiftly-sketched forms help to trigger the excited pace of this spirited travel scroll. Perhaps they are also indicative of a more dazzling artistic personality, in contrast to the rather introspective artistic character of Ma Lin.

Pattern

If we turn this comparison around and ask what it is that unites Hsia Kuei's and Ma Lin's works, we arrive at a third major component of abstraction: patternization. Patternization consists of the construction of forms through regularized or recurrent arrangements of line and wash, color and texture, and the generation of compositional designs through the repetition of these forms. What Hsia Kuei and Ma Lin have in common is a particular vocabulary of basic pattern units, or motifs. Like mini-compositions

from which the larger compositional design is generated, these basic units of pattern lie at the heart of traditional stylistic identities, and both of these artists display the style of the "Ma-Hsia school," named after Ma Lin's father, Ma Yüan, and after Hsia Kuei, who were colleagues in the Southern Sung imperial painting academy. Both create angular rocks—the "hard style" in Chinese landscape painting—from composite trapezoids, with a fondness for 120° angles (figs. 26b, 27e). River rocks are somewhat more softly rounded (figs. 26n, 27h), and low earthen embankments also show the softening effects of water (figs. 26m, 27i). Deciduous trees are consistently elongated and repeatedly bent and twisted at angles that parallel, and sometimes can hardly be distinguished from, the contours of nearby rocks (fig. 26f).

Like texture strokes, these units were derived from nature and simplified; nature's essentials were extracted, its details eliminated. Such units of pattern were closely associated with what the Chinese artist sought both in nature and in art, not endless detail but underlying essence. By abstracting generalized patterns from the myriad forms of nature, the Chinese artist developed and displayed his insight into nature's regular working principles. Thus, the activity of painting afforded an approach to abstract spiritual truth through the study of material form. The Chinese ancient spiritual reverence for natural pattern is expressed in the unrivaled classic on aesthetics, Liu Hsieh's *The Literary Mind and the Carving of Dragons*, from the early sixth century: "*Wen*, or pattern, is a very great power indeed. It is born together with heaven and earth. Why do we say this? Because all color-patterns are mixed of black and yellow, and all shape-patterns are differentiated by round and square [the colors and shapes of heaven and earth, respectively]. The sun and moon like two pieces of jade manifest the pattern of heaven; mountains and rivers in their beauty display the pattern of earth. These are, in fact, the *wen* of Tao itself."[5]

Chinese paintings are composite by nature, their design generated through the repetition and variation of basic units of pattern. In a complex landscape composition like Hsia Kuei's *Pure and Remote Views*, dots congeal into leaves, which are aligned with linear trunk and branching systems to form trees, which cluster into groves, which are knit together with land formations to generate larger and smaller patterned areas, from which the artist builds his grand compositional design. This repetition contributes to the visual and aesthetic unity of the Chinese painting and to the undefinable sense of "rightness" that an excellent painting presents to the viewer. But the life of a painting lies still more in its variation-within-repetition, in the endless transformations of the artist's motivic vocabulary, making these regularized shapes paler or darker in tone, larger or smaller in scale, providing them with greater or lesser detail, executing them more or less cursively, setting them higher or lower on the scroll, and allowing patterned areas to take on exciting configurations of their own. In Hsia Kuei's work, the sequence of forms seems infinitely diverse, though all this grows out of his mastery of a limited vocabulary of motifs. Although his rocks are all variations on a given type and his trees are variants of only a few types, the viewer is hard pressed to find any two trees, at least among those set nearby, that really look identical, or to define precisely the number of leaf-types to be found, though there initially seem to be but a few. This insistence on diversity within sameness makes Hsia Kuei's painting beholden to pattern, both technically and aesthetically, without becoming particularly decorative or in any way trivial.

These few paintings emphasize anew that Chinese painting was largely a performance art. Skillful variation upon a known, traditional, and time-honored vocabulary, rather than upon the continual discarding and replacement of old visual themes, was

the ideal. The stylistic vocabulary varied from school to school, from region to region, but there was always an emphasis on basic vocabulary, practiced repetitively during the training stage of a young artist, and perpetuated over many generations with only gradual change. The basic building units that characterized a few other major landscape traditions are also worth mentioning here for contrast: the smooth-skinned, block-like rocks known from eighth century landscapes, and from later works executed in their manner (fig. 19); the puffy, cloud-like, earthen hills of Kuo Hsi (fig. 21); the softly-rounded, grassy hills of the Tung Yüan tradition (fig. 30); and the peculiar faceting of Ni Tsan's flattened, seemingly ephemeral forms (fig. 32), which may have had their source in the now-lost tenth century styles of Ching Hao and Kuan T'ung.

Figure painting, too, with its emphasis on simple figure-ground relationships, tended to generate compositions through the repetition of like forms, similar enough to constitute a linked, rhythmic sequence, yet varied by posture and placement in space (fig. 15). The artistic urge to generate forms from a limited vocabulary of abstract shapes can be traced all the way back to the Shang bronze shaman (fig. 9), whose surface decoration shares the same "c-spiral" and "t-spiral" patterns that make up the background, but which are contrasted in scale, density, and composite tonality. The horns which the shaman has taken on as part of his ceremonial garb are but an outgrowth of the background spirals, and the bird-claws worn over his hands repeat the secondary background motif of "hooked quills" (fig. 9a). The body itself is an extension of the curvilinear system of decor. Later figure painting, as well, had its traditional patterns, its regularized basis of construction. In the Buddhist pantheon, the validity of these figures as sacred representations was enforced by a code of proportions so strict that little difference can be found between such different representational media as painted walls and three-dimensional sculpted figures (fig. 16). Pattern by pattern, convention by convention, the modeling of broadly rounded eye sockets, almond eyes, bowed lips, and so forth, match all but perfectly. Many of these configurations, moreover, corresponded with ones used at the same time in secular figures, and even the stylistic contrasts between religious figures of different hierarchical status had their secular counterparts in distinctions between social classes. Such consistency speaks of broadly used representational schema that characterized the prevailing style of a period and changed only slowly over time, enabling modern art historians to gauge somewhat accurately the date of execution of early works of art.

Specific conventions existed both for human forms and for drapery. In the early T'ang, for example, the traditional manner of rendering the ear included a fold that looks somewhat disturbingly like an exterior bit of tubing (fig. 16a). Not until the latter half of the eighth century was this pattern brought closer to nature, integrating this fold into the ear with a v-shaped notch at the upper end of the structure, a convention which then persisted for many centuries.[6] The presence of this v-shaped convention in a painting attributed to Yen Li-pen (fig. 12c), who lived in the early seventh century, helps to establish the earliest possible date for the execution of this painting as more than a century after Yen's death. In the seventh and eighth centuries, drapery folds below the elbow were usually indicated along the upper side of the sleeve by broken contour lines, along the lower side by a continuous line with some wiggles included or with a single break in the contour. The sleeves of Hsiao I, the attendant monk, and Hsiao I's servants are all executed in a style inconsistent with that period. With much too complex, angular, and broken a contour, these drapery conventions are datable to the tenth or eleventh century. This painting may represent an early Sung copy of a seventh century original, and it illustrates how, in even the best copywork, while the

general compositional design was accurately maintained, the artist adhered to those basic patterns which he had practiced since youth. Two later renditions of this painting incorporate unrelated patterns into the execution of drapery folds, one parading a mannered version of Chou Wen-chü's "tremulous" brushstroke (fig. 13a), a tenth century convention derived directly from calligraphy, and used here in a sixteenth century painting; the other employing the "plain-line" style of Li Kung-lin (fig. 14a), an eleventh century convention in a sixteenth century painting. But these two later examples represent a different phenomenon from that of the earlier work, namely the pleasure taken by later, art historically conscious painters in the eclectic mixing and matching of past styles, applying the drapery patterns of one historical master to the compositional design of another. A similarly eclectic blend of patterns may be found in art historically conscious landscape paintings like Wang Meng's *Secluded Dwelling in the Ch'ing-pien Mountains* (fig. 31), which wraps a Kuo Hsi-inspired composition (cf. fig. 21) in brushwork based on Tung Yüan (cf. fig. 30). Before considering compositional design, we should briefly note one further type of compositional unit without which such designs could not be generated: empty spaces, or voids.

Voids

Voids are the ultimate in visual abstraction, and they contribute immeasurably to the suggestive quality of Chinese painting. In figure painting, for example, the artist typically left the spatial environment to the viewer's imagination, using the empty areas between the figures as carefully measured intervals (figs. 10b, 12, 15). These intervals established expressive visual tensions within the painting and regulated its rhythms, like timing regulates the rhythm of a musical composition. Skillfully handled, a void could give focus to a central event or register the intensity of psychological interaction between two figures. The amount of "personal space" surrounding a figure could express the greater (figs. 10i, 15b, 23f) or lesser (figs. 10h, 15c, 23j) degree of individuality and social significance afforded that figure. In calligraphy as well, the measured intervals between strokes were regarded as critical, and connoisseurs often suggest that one should concentrate on the spaces between lines rather than on the lines themselves to best judge and appreciate the formal arrangement.

Not all Chinese paintings attached such great significance to the role of voids. The earliest pictorial designs seemed to have placed little special value on empty space, and both the Shang bronze drum (fig. 9) and the Han funeral from Ma-wang-tui (fig. 10) display what is known as *horror vaccui*, or "dread of empty spaces." In some later paintings, too, like Wang Meng's landscape (fig. 31), paper was but a neutral ground for a torrent of brushwork, for a dense network of ink tones and textures that left little room for voids except between the lines. In many landscape paintings (figs. 27, 29), however, voids took on an added significance, expressive of the abstract Tao itself.

Even closer to the Tao than the solid mountain was the ephemeral mist that rose from its slopes, known as the *ch'i* or "life-breath" of the Tao, coursing through the veins of the mountain, congealing into pools of water, and dispersing into pale atmosphere. In Han through mid-T'ang painting, clouds remained localized and hard-edged (figs. 10n, 19g), and not until the eighth century did the rise of ink-wash and splashed-ink techniques make it possible to suggest the softly atmospheric qualities of pale mist and the subtle interpenetration of solid and void. (cf. figs. 21, 29). Working in the style of the

eighth century Taoist Wang Mo and Master Ku, the Ch'an Buddhist Yü-chien treated ink and paper like *yang* and *yin*, drawing matter from the void like a conjurer (fig. 29). No Chinese critic would look on the voids of this painting as mere neutral ground, but as the Tao itself, giving birth to still-moist mountains and clinging to its slopes in the form of nourishing vapors. The very process of creation and destruction is suggested here, the lingering clouds threatening to dissolve the mountains once again and draw them back into their fold. A century later, the unworldly purist, Ni Tsan, "treasuring his ink like gold," took the role of empty paper to still a greater extreme (fig. 32). His voids seem recalcitrant, stingy, scarcely willing to disclose the tainted substance of worldly matter.

The role of voids and solids in establishing a strongly contrasting figure-ground relationship is critical to the assertiveness of compositional design in a Chinese painting. No painting can be said to lack compositional design, but our awareness of it is suppressed in a naturalistic painting like Ma Lin's (fig. 27), where the tonalities are subtly and gradually varied, where the forms of the painting are tightly arranged, and where the landscape itself seems not to betray any conscious design. In Wang Meng's landscape (fig. 31), the strength of design is suppressed somewhat by the artist's scarcely restrained interest in brushwork, texture, and tonal effects, spread broadly and fairly evenly over the entire surface of the painting. And in Ni Tsan's *Jung-hsi Studio* (fig. 32), where the dominant white void of the paper invades even the few pale, dry brush lines and where the few traces of ink are spread sparsely across the scroll, the strength of design is purposely held to a minimum. On the other hand, in landscapes like Shen Chou's (fig. 33) and Wang Yüan-ch'i's (fig. 18), and in figure paintings like *Hsiao I* (fig. 12), *Ladies Playing Double-Sixes* (fig. 15), and *Buddhist Patriarch and Tiger* (fig. 20), where solids and voids are both strongly expressed and sharply contrasted, our awareness of design is greatly heightened.

Compositional Design

Even with a limited selection of elements, the master painter may create a striking compositional design and an engaging interplay of similar and contrasting parts. Consider the painting of a Buddhist priest, Feng Kan, and his "pet tiger" (fig. 20), in which the elements are arranged to define the two contrasting figures: the surface of the priest's robe is composed of wet wash surrounded by dark outlines, while the coat of the tiger is created by dry, scratchy brushwork with pale lines for the interior markings. The contrast could not be simpler nor greater. Still, the isolation of these calmly sleeping figures in the midst of empty, unpainted space emphasizes their close relationship. They are arranged in a roughly circular shape, interpenetrating along the double-bend of an s-shaped curve formed by the priest's elbow and the tiger's head, and their tightly interlocking structure emphasizes their essential harmony. With their two round heads placed one over the other, the juxtaposed patterns of the entire ensemble is strikingly similar to the ancient Chinese symbol of *yin* and *yang*, (☯) , an archetypal design representing unity within diversity. The similarity may be only coincidental, which would suggest even more strongly the effectiveness of this particular configuration in expressing the Chinese concept of harmony. For this is, after all, the theme to which the artist has given form here: it cannot be stated unequivocally, but the tiger represents for

the Ch'an Buddhist the true, untamed, uncorrupted self, in contrast to the civilized self that this sect trusted only in moderation; the union of man and tiger shown here represents the integration of the rational and spiritual aspects of the enlightened human being.[7]

In analyzing a painting in this manner, the viewer becomes the one who abstracts, who strips away the lesser details and selects from the painting its essential pattern. But usually, we may be sure that the artist intended to provide us with this compositional framework, having built up the details of the work around some primary structural configuration. Again and again, Chinese artists wrote of the need to start a painting, especially a complicated one, with a few essential divisions or contours, laid down in pale ink at the outset and establishing a unified design that the lesser motifs later generated must not obscure. Often, paintings which seem totally unrelated by virtue of color, texture strokes, or their basic vocabulary of composite units, reveal significant similarities in terms of their compositional design. A few such related designs can suggest a great deal about the historical development of Chinese landscape composition.

In *The Wang River Villa* (figs. 17, 18), because of the clear separation of solids and voids, it is easy to recognize the organizing structure as a series of linked circles, which have been described by modern art historians as "space-cells." The primary subjects of the scroll are the architectural dwellings and gardens, built in the eighth century along the banks of the Wang River by Wang Wei, the painter of the original *Wang River Villa* scroll. Wang's twenty poems, written to accompany twenty choice spots illustrated in the painting, equalled in fame both the villa and the now-lost original painting of it. In the "space-cell" structure, the encircling waters and diminutive mountains are but the supportive features of the painting, designed to focus the viewer's attention on the human elements and to provide a sense of continuity throughout the scroll as one moves from one setting to the next. This convention dates back at least to the fourth century A.D., and by the time of Wang Wei's now-lost original version of this painting it was already a conservative, perhaps archaistic, device. A ninth century critic described it as "trees and rocks used to show off a setting by encircling it," a convention he recognized as primitive by the standard of his times, when trees and rocks and landscapes in general were themselves becoming the primary focus of Chinese painting.[8]

More representative of late eighth–early ninth century landscape composition is *Ming-huang's Journey to Shu* (fig. 19), already described in terms of ground planes and points of view. Its "stage-like foreground divided by flowing water into three small staging units, right, center, and left" (p. 37) reflects the lingering influence of the "space-cell" convention, which is now in the process of being transformed. The staging areas are no longer fully encircled, although a few diminutive foreground trees still remain, reduced in scale so as not to block the view. The mountains at the rear of this area have taken on greatly expanded proportions, equal in emphasis to the human activity of the foreground. The landscape has begun to express an independent life of its own and to dictate the compositional structure. With its division by the flow of water into three vertical sections, and with the linkage of the foreground by bridges, the compositional design is strikingly similar (probably intentionally) to the Chinese written

character for mountain, 凵, a tri-partite structure usually described in terms of a

central "host" mountain and flanking "guest" mountains on both sides. While there is a shift of emphasis toward greater verticality, the proportions of the painting still retain

a horizontal stress, perhaps indicative of an origin in wall or screen painting popular in T'ang times.

By the time of Kuo Hsi's *Early Spring* (fig. 21), dated 1072, the vertical hanging scroll had come into being and rivaled wall and screen painting in significance, being perfectly suited to the Northern Sung taste for towering, cosmic landscapes. The human element became no more than an enlivening accent, an indicator of the monumental scale of nature. A single, dominant mountain which twists about the central axis and reaches from the foot to the peak of the painting forms the primary structural feature of Kuo Hsi's *Early Spring*. But the tri-partite structure of *Ming-huang's Journey* is still to be found: although the sides of the landscape have been trimmed and compressed in the evolution of late T'ang–early Sung painting toward sheer verticality, the vestigial flanking mountains and the twin corridors which extend into depth along both sides of the central ridge still remain. The chain of horizontally-linked "space-cells" has been abandoned, and it is a vertical framework about which the secondary scenes of human activity are now loosely hung (fig. 21a, d, i, k).

The relationship between these three paintings is an indirect one. Their similarities are not the product of direct influence but a reflection of gradual evolution and partial change over time in the manner of handling similar artistic problems. On the other hand, several of Wang Meng's surviving landscapes, including his *Ch'ing-pien Mountains* of 1366 (fig. 31), were heavily indebted to the particular accomplishments of Kuo Hsi, borrowing Kuo's principle of a single dominant mountain that rises the full height of the scroll with a strongly expressed rhythmic movement, "like the back of a dragon." But Wang's primary interest, like that of most post-Sung artists, lay less in landscape forms and compositional structure than in calligraphic brushwork. In order to cover his painting surface more fully with densely textured ink, he dispensed entirely with the vestigial "guest" mountains and empty spatial corridors, squeezing the central mountain within the increasingly narrow confines of the scroll. Too much of the paper is now draped with Wang's network of ink for his mountain to swing freely through space as Kuo Hsi's did, and the strongest impulse in the painting now comes from linear brushwork surging two-dimensionally over the painting surface.

Figure painting, too, sometimes perpetuated particularly successful designs despite gradual alterations with time. While not immediately apparent, *Hsiao I* (fig. 12) and *Ladies Playing Double-Sixes* (fig. 15) share the same basic composition: both are focused on a pair of protagonists set facing each other, with onlookers and serving figures placed behind and to the left. In *Double-Sixes*, note the pale strip of lighter color (fig. 15b) which separates the pair of figures on the right from the rest of the scroll—these two figures were once cut off and mounted separately, and not until 1960 were they restored to their original position.[9] We may be all but certain that one or two such figures once also stood at the now badly damaged beginning of the *Hsiao I* scroll, providing the balanced symmetry missing today but so much a part of the compositional aesthetic of its time. *Hsiao I* is attributed to a seventh century artist, *Double-Sixes* to an eighth century master and, while both are surely later copies, a popular T'ang formula underlies the composition of each. The differences between them, which will be discussed later in terms of compositional dynamics, may be sufficient to demonstrate the surprising accuracy of the original dates suggested by their attributions.

Some compositional designs were especially associated with particular periods and seem to reveal something of the general aesthetic of the age in which they emerged: the balanced, almost classic symmetry of *Hsiao I* (in its original state), *Double-Sixes*, and

Ming-huang's Journey to Shu are typically T'ang (figs. 12, 15, 19); the informal and potentially evocative "one-corner" arrangement, in which the major elements were located in a lower corner of the painting in contrast to a minor emphasis or void in the opposite upper corner, was a common vehicle for Southern Sung sentiments (figs. 23-25); the popular Yüan compositional formula, dubbed "hills beyond a river," in which an empty expanse of middle-ground water separates two land masses, far and near, and suggests isolation and loneliness, expressed well the dominant mood of the scholar-painters of that unhappy period (fig. 32).[10] These designs, even when adapted by later artists, usually continued to retain something of the flavor of their age of origin and were often perpetuated for that very reason. Other compositional schema had no such specific associations but also managed to survive, in part because they were able to accommodate the shifting tastes of time. Chao Po-su's *Reading in the Open Pavilion* (fig. 23), for example, presents the general design of a scholar placed centrally in his studio and surrounded by landscape, but it also incorporates the "one-corner" formula of its own time of execution, the Southern Sung period. Tao-chi's *Man in a Hut* (fig. 34) employs the same centralized design, but the rippling mountain form which rises up the album leaf and encircles the artist's studio expresses a later, far more dynamic vision, perhaps borrowing something from Wang Meng's linear transformation of Kuo Hsi (figs. 21, 31).

With the frequent repetition and standardization in later times, such compositional designs became the stuff of traditionalism in an art which deeply savored tradition. Like written characters appearing again and again, done by different artists in different periods, the traditionalization of such designs masked the individuality of artists and often concealed even the period of their execution, making the authentication of Chinese paintings an especially risky endeavor. In attempting to date a painting by its style, even to identify a general time period for it, or to sense the artist's contribution to its design, we must once again deal with the notions of variation within tradition and of styles within styles. As in the search for individuality in Chinese calligraphy, the historically-oriented viewer must strip away the design similarities in conception which lie at the heart of individual and period styles. For example, in the design of Wang Wei's *Wang River Villa* (figs. 17, 18), the circular arrangement of landscape motifs in the so-called "space-cell" convention reflects the unsophisticated spatial techniques of an early, "primitive" artistic age. The rubbing illustrated here (fig. 17), taken from a 1617 stone engraving, probably remains faithful to the now-lost eighth century original.[11] But while Wang Yüan-ch'i, in 1711, relied on the 1617 version as his model (fig. 18), in his hands the "space-cell" device became the vehicle for an extraordinary display of compositional dynamics, a *tour de force* which to this day, by Chinese art historical standards, seems sophisticated and "modern." In the rubbing, if the ground plane tips up awkwardly, the horizon line at least runs level and straight, bound by naturalistic considerations although not yet in command of them. But in Wang Yüan-ch'i's primitivistic rendition, the horizon line pitches up and down and sometimes splits apart along lines of forceful diagonal thrust (fig. 18a)—a bold treatment of formal design and two-dimensional rhythms, unfettered by naturalistic strictures, and historically indebted to the innovations of the sixteenth century master, Wen Cheng-ming. Wang makes his composite mountain forms seem to heave and roll, to arch apart and huddle together with a degree of personified energy not found in the rubbing and not yet imagined in eighth century landscape painting, turning his almost nine-hundred-year-old prototype into one of the crowning achievements of later Chinese painting principles.[12]

Compositional Dynamics

Almost every compositional arrangement establishes some internal dynamic tensions—emphases or directional thrusts that are felt by the viewer even if not consciously recognized. In *Chopping Bamboo* (fig. 24), for example, which was said to represent the moment at which the Ch'an priest Hui-neng attained enlightenment, Liang K'ai has directed our attention to the action of chopping by the triangular disposition of the figure who points in that direction, by the priest's unswerving concentration on that activity, and by the similarity between the priest's knife and the segment of bamboo before him, which indicates a special relationship. The knife and bamboo segment are identical rectangles, but they are contrasted in execution. One is represented by exterior outline only, the other by an interior wash. For the philosophically-oriented, this contrast may seem to represent the dichotomy between being and action, between growth and destruction. In chopping bamboo, Hui-neng was said to have suddenly overcome or resolved all such worldly distinctions, and the artist fixes the attention of the viewer (who, originally, would have been a Ch'an monk) on this contrast, until he can do the same. There is, too, the tension between the material objects of the lower left half of the painting and the void area of the upper right. While not knowing if Liang K'ai had such symbolic interests in mind, we might speculate that he has directed Hui-neng's attention, and ours, through the knife and bamboo, toward that abstract area beyond the realm of material being and into the realm of pure spirit. The creation, repeated copying, and meditative viewing of such paintings were common Ch'an exercises, both in China and Japan, and the unity of form and content found in the best of these works underlies the effectiveness of the practice.

Dynamics, literally meaning "force" or "power," may be thought of as the manipulation of the viewer's attention, guiding the eyes over the surface of the painting in directions and at rates intended by the artist. Our discussion will include three aspects: tension, balance, and rhythm.

Dynamic tension. A work need not be spatially or otherwise technically sophisticated to be dynamically effective. The wall designs of the Wu family shrines (fig. 11), made of carved stone in imitation of painting, are entirely primitive regarding plasticity and perspective, and less developed in these regards than the Han funeral banner (fig. 10) done some three hundred years earlier. And yet they set a high standard for dynamic design, created from simple geometric forms, swelling curves, triangular wedges, vertical blocks, and so forth. One of their scenes depicts an episode unsurpassed for drama in all of Chinese history: the attempted assassination of the King of Ch'in in 227 B.C. As told traditionally, the tyrannical King was the villain, while his assailant, Ching K'o, was the hero, attempting to save his native state of Yen from ruthless extermination at the hands of Ch'in.[13]

Ching K'o came to Ch'in bearing gifts designed to gain him access to the King and to allay the King's suspicions: the severed head of a general hated by the King, carried in a box, and a map of Yen, needed for the Ch'in invasion; rolled up in the map was Ching K'o's dagger. The plot fared badly from the start. On entering the throne room, Ching K'o's young retainer began to quake with fear, alerting the King to danger. On unrolling the map, the King spied the dagger, but Ching held him firmly by the sleeve, putting the dagger to his breast—and then he hesitated, hoping to extract a bargain rather than kill him. In this moment, the King lurched back, his sleeve tore off, and thus began a mad chase, Ching K'o pursuing the King around and around the great bronze pillar of the

throne hall. As the fearful King had trusted not even his own troops, no one bearing arms was permitted near the throne, and so the King was left to his own devices. His ceremonial sword was too long to draw from its scabbard, so he merely continued to flail at Ching K'o with his hands and to keep the pillar between them, until his unarmed court physician stepped in, battering Ching K'o with his medicine bag. This gave the King the opportunity to unsheath his sword at last and to strike Ching K'o, who in desperation hurled his dagger at the King, only to have it hit the pillar. At this, the King and his soldiers finished off the hero. Soon after, Yen and all of the other remaining late Chou states fell victim to Ch'in, and the King became the much-hated and feared First Emperor of China.

The details of this episode, as related by the King's physician, are charged with energy and emotion; how can a single two-dimensional scene capture the flurry of activity, the hope and despair of this historic moment? Simple forms and direct relationships provide the solution. In the right foreground, Ching K'o's young assistant has literally fallen over with fright (fig. 11b), helpless to regain his upraised feet, a useless horizontal curve amidst a geometry of vertical blocks and diagonal lunges. Although the King is near (fig. 11c), the assailant's form curves harmlessly away. He clings still to the map case (fig. 11a), while the opened box at his feet exposes the profile of the general's severed head (fig. 11e). These now seem secondary to the action that swirls about them, and they serve only to help identify the episode. Central to all of this activity is the stationary bronze pillar (fig. 11f), that obstacle to Ching K'o's efforts. Already, Ching K'o (fig. 11h) and the King are separated by its form. Ching K'o still lunges forward, his teeth bared and his arms outstretched, but his hands are now empty and his rising thrust is fully encountered by the low, well-braced diagonal of the King's athletic physician (fig. 11i). Ching K'o and the physician provide the only complex, overlapping form in the entire scene, and Ching K'o is shown as hopelessly entangled while the King withdraws unencumbered to the safety of his waiting bodyguards. The King is given the form of a receding triangle, the corner of his robe marking his vanishing vulnerability. His clearly-displayed, torn-off sleeve (fig. 11d), the remnant of which lays by his feet, records Ching K'o's lost opportunity. Lodged deep in the pillar, and blocked in its path toward the King, is Ching K'o's dagger (fig. 11g)—a pointed reminder of what might have been.

The effectiveness of certain dynamic relationships can best be appreciated by comparing closely related examples. In *Hsiao I Seizes the Orchid Pavilion Manuscript* (fig. 12), a strong psychological relationship is established between the two protagonists (for their story, see p. 22). Both lean forward, closing the distance between them and staring into each other's eyes. The psychological edge that the imperial envoy exercised over the unwitting priest is revealed through their placement and postures. Hsiao I has been set well above Pien-ts'ai, enabling him to function from a position of strength. His knowing determination is expressed by the way that he tucks in his chin, plants his feet firmly, and readies his shoulders as if for a physical charge. His concealed hands suggest his hidden purpose, while Pien-ts'ai's open gesture, in this case, seems to speak of his gullibility.

Two free variations on this scroll (figs. 13, 14), perhaps both done in the sixteenth century, show by their defects the psychological power of the original. In one (fig. 13), an anonymous work, Hsiao I no longer sits with commanding elevation. His weight is back, his left leg is dropped, he leads with his chin, and his shoulders aim nowhere. No flicker of determination appears on his quizzical face. It is now the priest who sits higher up, although his feeble gesture shows no command. In a third version (fig. 14),

attributed to Ch'iu Ying, there is little more than a half-serious reference to the original. The athletic envoy of the earlier scroll, whose eyebrows were knit into a scowling glare, is here but a squat-bodied, plump-faced creature, not a genuine conveyer of human passion. The two figures are no longer even facing each other, and no direct psychological interaction takes place. They face partly forward, as if introducing themselves to an informed audience, or introducing their audience to the *Orchid Pavilion Manuscript*, the object of their contention, whose text is inscribed on the scroll following the painting, rather than fully playing out their roles.[14]

The older version of *Hsiao I* (fig. 12) is a genuine masterpiece, but it has its flaws in terms of handling the drama and drawing the viewer into the scene. Two lesser figures are placed to the left, another sits in the center, and one or two more probably once stood on the right. Somewhat formally but nevertheless effectively, these figures frame the protagonists, forming an axis that places them at the center of attention and implies the participation of the viewer in closing the arrangement. However, the central position of the attendant monk—directly facing the viewer—visually interrupts the duel taking place between the envoy and priest. The artist's attempt to minimize this by elevating the monk's position introduces a disturbingly awkward spatial relationship, since the ground plane seems severely tipped up although each individual is shown from a level point of view.

A solution to this problem is found in *Ladies Playing Double-Sixes* (fig. 15), which brings this classic design to a state of perfection. In this work, two stout ladies of the imperial court are engaged in playful rivalry. The one with her back to the audience seems intent on a crucial move, while the other watches carefully, her hand frozen in a gesture of anticipation. The axis-in-depth of the painting has been subtly shifted, leading back along a diagonal line rather than vertically upward. The central attendants are placed lower down and behind the major figures, where they establish a more natural sense of depth and no longer intrude into the area of central emphasis. The space between the two major figures is now occupied solely by the gaming board and by two expressive hands—one initiating, the other responding. We, the viewing audience, now look over the shoulder of the active player, having to crane our necks a bit to see what move she will make, the artist visually teasing the audience in order to secure its involvement.

Double-Sixes also makes important adjustments to the scale of the figures and to the intervals between them. In *Hsiao I*, as we read laterally along the scroll from right to left, the distance from each figure to the next is almost identical (fig. 12g). No particular emphasis is given, no major or minor grouping is established by virtue of placement. What organizes the figures into groups is their scale, the servants on the left being much smaller than the other three figures. By virtue of scale, the three larger figures form a triangle, but the two protagonists are therefore obliged to share their would-be spotlight with a minor figure, an attendant monk not even mentioned in historical accounts of the episode. The tame presence of this monk further dilutes the intensity of the engagement between the envoy and priest. In *Double-Sixes* (fig. 15), the relative scale of figures is much more naturalistic and the arrangement of figures more lively. If we imagine the central pair of attendants as set somewhat back in space (fig. 15d), then the figures appear to be grouped in four pairs, and the relatively greater distance separating the two members of the central pair (fig. 15c) affords these seated matrons a greater degree of individuality than is found in any of the other pairs. The potential rhythmic monotony in the lateral arrangement of figures, to which *Hsiao I* fell prey (fig. 12g), is avoided here (fig. 15a) by closing the distance between the two central groups and par-

tially overlapping them, and by separating the right-hand pair in depth while leading them toward the center along a split axis. The artist's mastery of visual tension is so finely attuned that he brings to a trivial moment in the court-women's quarters a momentary intensity which rivals that of the historic confrontation between Hsiao I and Priest Pien-ts'ai.

No brief discussion can encompass all the numerous varieties of dynamic relationships which manipulate the viewer's eye and give rise to visual tension, but throughout the works illustrated here can be found several primary dynamic spatial configurations: thrusting and blocking, in *Ching K'o* (fig. 11); separation and linkage, in Ni Tsan's isolated land masses, bridged by the vertical extension of foreground trees (fig. 32); enclosure, as in the figural arrangement of *Double-Sixes* (fig. 15) and in each "space-cell" of *The Wang River Villa* (figs. 17, 18); interlocking, as in the *Buddhist Patriarch and Tiger* (fig. 20), in the relationship of land and water in Shen Chou's *Return from a Thousand Leagues* (fig. 33), and in the chain of "space-cells" in *The Wang River Villa* (figs. 17, 18); focusing inwards, as in *Hsiao I* (fig. 12), *Double-Sixes* (fig. 15), and in the two figures set in landscapes by Chao Po-su (fig. 23) and Tao-chi (fig. 34); radiating outwards, from the point of view of these two latter figures (figs. 23, 34); rising and falling, in the mountains of *The Wang River Villa* (fig. 18); distension and compression, in Hsia Kuei's *Pure and Remote Views* (fig. 26h, k) and in *The Wang River Villa* (fig. 18b, c). In a complex work like Kuo Hsi's *Early Spring* (fig. 21), several dynamic patterns may vie with one another, its mountains rising impulsively and twisting about in space, yet being stabilized by the four peripheral scenes arranged about them (fig. 21a, d, i, k), and by the two horizontal land-bridges linking the "host" and "guest" mountains (fig. 21c, j). In other works, the dynamic energy may be transferred from the primary figures themselves to the highly-charged brushstrokes that compose them, as in *Hui-neng Tearing Sūtras* (fig. 25) and Wang Meng's *Ch'ing-pien Mountains* (fig. 31). Color, as well as shape, may contribute to the visual activity of a painting. Even a small dot of it may prove sufficient to draw the eye away from the rest of the painting, as does the red ribbon worn by the cat in *Cat and Peonies* (fig. 22f). When carefully blended and neatly enclosed (figs. 19, 22), it may heighten the solidity of tightly-knit forms, diminishing the dynamic level; but when splashed loosely over these forms (pl. 3) it may inherently destabilize and activate them. Even without hue, the dramatic shifts of tonality in Yü-chien's *Mountain Village* (fig. 29) are sufficient to capture something of nature's own explosive energy.

Dynamic balance. As all of these examples show, Chinese artists and critics were conscious of and sensitive to the dynamic forces of composition, but even more important to them was the principle of balancing those forces. Conditioned by the conceptual principles of *yin* and *yang*, Chinese artists habitually thought, wrote, and painted in terms of complementarity: paper and ink (figs. 29, 32), line and wash (fig. 31), solid and void (figs. 15, 29), areas of a painting alternately dense and sparse (figs. 18, 26), the relation between heaven and earth (fig. 30) and between mountains and water (fig. 32, 33), mountains that rise and fall in rhythmic sequence (figs. 18, 26, 30), the relation between "host" and "guest" mountains (figs. 19, 21, 30), the role of people in nature (figs. 23, 34). Nothing is more conspicuous about a painting like *Patriarch and Tiger* (fig. 20) than its balance of opposites—dark and pale, wet and dry, repesenting man and nature—all fused into a harmonious spiritual union.

Balance does not imply a lack of tension but the matching of forces and counterforces that achieve stability in a painting. Heightened internal tensions do not prevent

the achievement of a fine dynamic balance: in the highly dramatic *Ching K'o* (fig. 11), for instance, the intersecting figures to the left of the vertical pillar are complemented by the flowing, circular arrangement on the right, and the design as a whole is quite stable. Nor does the subtle irregularity that makes *Double-Sixes* (fig. 15) so effective disrupt its classical formal stability. Indeed, built into *Double-Sixes* are innumerable complementary balances: one of the two players is active, the other receptive; the major group is seated, surrounded by lesser, standing groups; younger, energetic servants on the left, both females placed close together, and an older, more stable pair on the right, one a female and one a eunuch, separated in depth; of the central standing pair, one who looks down at the players and one who directly engages the audience with her glance; and so forth, all of these combined contrasts providing a sense of coherence, tight-knit unity, and formal completion.

Like *Double-Sixes, Reading in the Open Pavilion* (fig. 23) is a study in formal balance. It adheres to the "one-corner" formula popular in the Southern Sung period, with a major emphasis in the lower left half—where the elements are larger in scale, darker in tones, and richer in detail—complemented by a minor motif toward the upper right, providing balance through the pairing of opposites. A further basis of stability lies in the arrangement of the component parts of the painting along several intersecting axes. One set of complementary axes is established by the horizontal baseline of the architecture, parallel to the picture plane, and by the axis-in-depth running "perpendicular" to this, following the line of the walkway and the right side of the pavilion. A second set of axes bisects this one at quarter-angles. One of these is established by the architectural and human elements of the painting: the terrace in the lower right, the central hall, and the inner corridor, reinforced by the servant boys, the seated gentleman, and the maids-in-waiting. Balancing these human elements are the natural elements of the painting, set along an axis perpendicular to the "one-corner" disposition of the work, stretching from the pine and rocks in the lower left corner, through the bamboo and decorative rockery in the middle ground, to the water and distant mountains. More or less central to all of these forms is the Chinese gentleman, an idealized figure in an idealized world that seems to exist primarily for his sake. The man-made elements are but extensions of his authority—the painted scrolls and screens, his stack of books, the elaborate architecture, and the serving figures (the women, typically, huddling indoors, shoulder to shoulder, and lacking any individuality, the boys taking time to put in a word and glance of their own). The landscape motifs, moreover, are traditional symbols of his virtue: evergreen pines and weathered rocks reflecting his ethical steadfastness, bamboo related to his cultural refinement, water and mountains providing for him a source of universal principles. He is the stable center of all that happens about him, a balance for all contrasts. It is this very ability to harmonize these contrasting forms and forces that makes him the master of all he surveys and places him at the pinnacle of Chinese society.

Even more remarkable, given its intense dynamism, is the balance of forces in Tao-chi's *Man in a Hut* (fig. 34); its swirl of lines and dots seem to emanate from the imagination of the figure, the artist himself, seated quietly at their center. In this painting, it is only the stability of the figure that balances the forces of nature, and yet the serenity of the figure seems all the more profound for the storm of natural energy that surrounds but does not disturb him.

Dynamic rhythm. One last significant aspect of dynamics remains to be considered: rhythm, or the sequence of movements in a painting perceived *in time,* with speeds

(fast or slow), transitions (abrupt or gradual), sequences (continuous or discontinuous), and intervals (regular or irregular) established by the structure of the work. Individual brushstrokes are an important contributor to the rhythm of a work. As already seen in our discussion of calligraphy, some lines are slow and regular (figs. 3, 5), others have sudden starts and stops (figs. 4, 6), some seem to flow gracefully along (figs. 5, 7), others spin rapidly over the page (fig. 8), and still others tremble with pent-up inner force (fig. 6). In the angular clerical script (fig. 4), transitions are abrupt; individual lines and characters are isolated and establish a regular but discontinuous sequence, like the beat of a drum. With the curvilinear lines and movements of the cursive script (figs. 7, 8), come smooth, flowing transitions and rhythmic continuity, like the blending of string instruments.

In painting, individual lines constitute a primary source of rhythmic vitality, and in some paintings the linear rhythm seems inspired by their content: it has been said of Liang K'ai's *Chopping Bamboo* (fig. 24) that every stroke seems like chopping, strong and steady, and it might be added that in *Tearing Sūtras* (fig. 25) every stroke seems like tearing, fast and furious.[15] Some works that are highly linear, like Wang Meng's *Ch'ing-pien Mountains* (fig. 31), seem to be "all rhythm." Tonal changes also contribute to the temporal rhythm of a work, sometimes being smooth and gradual, creating a mood of quiet harmony (fig. 27), at other times being explosively dramatic (fig. 29). Compositional designs, too, are conveyors of rhythm, just as calligraphy is. In *Hsiao I*, as in the clerical script (fig. 4), the compositional arrangement is steeped in angularity (fig. 12h), and the figures are separated from one another by regular intervals that give rise to a steady, sequential rhythm and threaten to become monotonous (fig. 12g). In *Double-Sixes*, the lateral intervals between figures are adjusted so that they occur in an irregular, enlivening sequence (fig. 15a), while the vertical placement of figures follows a curvilinear rise and fall (fig. 15e); if not as rhythmically integrated as some examples of cursive script (fig. 8), at least this work shares the rhythmic flexibility found in the regular script (fig. 5). In *The Wang River Villa* (fig. 18), the regular, sequential appearance of architectural elements holds no special excitement, but the continuous flow of mountain chains and running water—rising and falling, leaning and turning, sometimes intensely compressed, sometimes stretching forth, splitting apart and linking up—provides the vehicle for a great display of rhythmic vitality. In *Reading in the Open Pavilion* (fig. 23), the axes which converge on the gentleman in the center seem to fix him in the midst of a static arrangement; alter any one of them and the balance of the painting will be shattered. In Tao-chi's work (fig. 34), on the other hand, the scholar seated in the center seems to draw his stability from the unrestrained rhythms that circle about him.

Handscrolls are meant to be viewed section by section, and in this format the rhythmic sequence of events is paramount, put on display as in no other type of work. Hsia Kuei's *Pure and Remote Views of Streams and Mountains* (fig. 26) is meant to be viewed as though one were really travelling through it. Throughout the scroll, the abstract forms of short swift brushstrokes, angular motifs, and rapid transitions in scale, tone, and placement contribute to the adventurous spirit of its narrative content. As always in a Chinese handscroll, the journey is made from the right to the left of the scroll, and the disposition of the landscape elements—vertical, diagonal, horizontal, facing toward the left, facing toward the right—must be read against this leftward horizontal progress. The opening passage, about as much of the scroll as the viewer should expose at one time, is framed by foreground boulders on either side (fig. 26a, d). The large boulder on the left blocks the traveler's forward progress, and a tree pointing back

to the right directs the eye over the terrain just traveled. A sequence of rising ridges leads back into depth, and the traveler is encouraged to remember a day's journey that stretches backward in time and space beyond the initiation of the scroll. The rock and tree on the left not only invite this momentary pause to recapitulate but also create a distinct juncture with the next scene, in which the first part of the journey comes to a resting point.

A second arm's-length of the scroll may now be unrolled, with rocks and trees again providing a framework and turning the traveler from his lateral journey onto a path that leads to the right, into depth. There, a comfortable looking pine-shaded temple invites us to settle down. Whereas the sequence of horizontal lines and fading ink tones of the opening scene suggested an on-going journey, here the tight enclosure by boulders and trees, the vertical arrangement of the pines and pathway, the darker ink tones, and the greater quantity of landscape and architectural detail all urge the viewer to slow down and inspect the painting. The traveler is invited to relax for a bit, perhaps to enjoy a vegetarian meal and to spend the night as the guest of the local abbot.

But the traveler must soon be off, perhaps the next morning, and a rock on the left (fig. 26g) points the way. This time, a ferry-boat awaits us, indicating a watery route that leads past a distant fishing village, set high up on the scroll, pale and far away. Its indistinct forms will be grasped only vaguely by the traveler, who may strain to see but is left to imagine as the boat flows smoothly and swiftly by. No sharp contrasts and few details slow the eye; only the long, smooth, horizontal contours of distant shorelines and the diagonal cliffs point the way forward. Unlike the previous two scenes, this one has no bounding framework, no abrupt conclusion, no clear ending at all. At land's end, all forms simply disappear and there is neither far nor near, only the water itself. For a while there seems to be no clear direction, as if we were caught in a fog or completely surrounded by water for an indeterminate amount of time. A sense of calmness ensues, until broken suddenly by three boats racing out of the distance. They move toward the right, which heightens the sense of impact and surprise. A foreground spit of land appears, below, and then—a gigantic bluff rises out of the water, slicing vertically across the scroll, filling the eye with its majestic scenery. Foreground, middleground and background are blocked, and the boat can go no farther.

Once again, strong verticals, dark ink tones, and detailed forms suggest a halt, and a safe inlet shows the place to disembark. A pair of gentlemen accompanied by a lute-bearing servant (fig. 26j) indicate that this is a scene to be savored, and perhaps an invitation will be extended to join them in a bamboo-shaded pavilion that stands not far away. From there, the path ahead may be viewed, framed by rising boulders and disappearing into rugged hills (fig. 26l). The mountain contours are piled deeper now, jumbled and pointed every which way, and the most difficult stretch of the journey seems to lie ahead. Beyond these hills, the remainder of the scroll is similar—full of dramatic shifts, alternating challenging mountain passageways and eye-opening views with well-timed spots to stop and catch our breath—but, of course, it is never simply repetitive.

While Hsia Kuei's handscroll turns rhythmic energy into a dramatic travelogue, punctuated with one exciting event after another, Wu Chen's short handscroll, *The Central Mountain* (fig. 30), illustrates a very different kind of rhythm and a very different aesthetic ideal. In this work, not the slightest degree of drama is present to disturb the absolute simplicity, the understated harmony of the painting. So unassuming as to seem not particularly significant to the uninitiated viewer, this work is in fact a rare masterpiece which, like Ni Tsan's work (fig. 32), brings to perfection that peculiar

value so highly prized by the Chinese scholar-painters: *p'ing-tan*, the "plain and insipid."[16] Whereas Hsia Kuei's work was anxious to please and broad in its appeal, Wu Chen's scroll was meant for the few, for those initiated into the rarified aesthetic of the scholar class. The brushwork, both of the landscape and the artist's inscription (fig. 30b), is devoid of significant modulation; produced with a worn-out brush, too spare to be truly elegant, it is reminiscent of the antique, disciplined simplicity of line found in the seal script (fig. 3). Abstract in the extreme, at least by Chinese standards, Wu Chen's work severely excludes all extraneous detail and limits its forms to trees and mountains, its means to simple lines and dots, flat gray wash, and—not to be overlooked— plain, slightly gray paper. The artist, it might be noted, was a man of the simplest tastes, a diviner by profession, a full-time student of *yin* and *yang*. His attentiveness to the principle of complementarity may be seen in the unadorned interplay of mountains and trees, heaven and earth, solid and void. The even distribution of forms throughout the painting is designed to suppress all irregularity and dramatic shifts, while the central mountain provides a calm, stable balance. Unlike Hsia Kuei's scroll, with its striking angularity and appealing variety of ink tones and spatial arrangements, Wu Chen's work is quietly unified by rounded, well-integrated forms and smooth, flowing rhythms. Its gently rolling mountains rise and fall with the rhythmic regularity of *yin* and *yang*, breathing with total effortlessness, relaxed and serene. Supreme in the virtue of self-restraint, no finer homage to the abstract principles of art and nature exists in all of Chinese painting.

Notes

Introduction

1. Burton Watson, trans., *The Complete Works of Chuang Tzu* (New York: Columbia University Press, 1970), p. 302.

2. See Meyer Schapiro, "Style," in A. L. Kroeber, ed., *Anthropology Today* (Chicago: University of Chicago Press, 1953), pp. 287-312.

Materials and Format

1. Cf. James Legge, trans., *The Chinese Classics, I: The Confucian Analects* (reissued; Hong Kong: Hong Kong University Press, 1960), p. 151.

2. The inkstone illustrated here is thought to be of the Sung period and it later belonged to the Yüan landscape painter, Huang Kung-wang, whose identifying inscription, "Ch'ih-an," is seen on the side of the stone. For more on inkstones, see Robert Hans van Gulik, *Mi Fu on Inkstones* (Peking: Henry Vetch, 1938).

3. In 1975, the first known fragment of an actual Shang clay-wall painting was excavated at Hsiao-t'un, near An-yang, site of the last Shang capital, from a building thought to have been an imperial jade and stone workshop. For a discussion and illustration of this small fragment, 22 cm. × 13 cm., painted on a lime surface with red lines and black dots, see *K'ao-ku*, April, 1976, pp. 264-72. In some cases, Shang walls and ceilings may also have been made of carved and lacquer-painted wooden panels bearing typical designs of the period, like those excavated in fossilized form during the 1930s from a Shang royal tomb at An-yang; for examples, see Yüan Te-hsing, "Conceptions of Painting in the Shang and Chou Dynasties," *National Palace Museum Bulletin*, vol. 9 (1974), no. 2 (May-June), no. 3 (July-August).

4. See chap. 2, note 13.

5. Paper made from hemp during the first century B.C. was recently found at Chung-yen Village, Fu-feng County, Shansi; reported in *Wen-wu*, September 1979, pp. 17-21.

6. For a report on Shang period thin-core lacquer fragments recently found at T'ai-hsi Village, Kao-ch'eng Country, Hopei, see *Wen-wu*, August 1974, pp. 42-49. Still more recent reports indicate that the history of Chinese lacquer wares may have begun well back in the neolithic period.

7. The most important surviving link between the decorative styles of painted lacquer and inlaid bronze and the embryonic style of landscape painting is a pair of painted lacquer coffins excavated from Han-period tomb number one at Ma-wang-tui, near Ch'ang-sha, Hunan Province, the same tomb which yielded figs. 10 and 36; they are illustrated in *Ch'ang-sha Ma-wang-tui i-hao Han mu* (Peking: Wen-wu, 1973), vol. 2, pls. 25-57.

8. For the sequence of re-copying that stands between figs. 5 and 7 and their now-lost original specimens, see chap. 2, notes 3 and 5, below.

9. The seals on fig. 20 are discussed in Shujiro Shimada, "Concerning the I-p'in Style of Painting—II," trans. James Cahill, *Oriental Art*, n.s. 8 (Autumn 1962): 131-32. Seals are examined in depth in Victoria Contag and C. C. Wang, *Seals of Chinese Painters and Collectors of the Ming and Ch'ing Periods* (1940) (rev. ed.; Hong Kong: Hong Kong University Press, 1966), and in Robert Hans van Gulik, *Chinese Pictorial Art as Viewed by the Connoisseur* (Rome: Instituto Italiano per il Medio ed Estremo Oriente, 1958), pt. 2, chap. 2.

10. The oldest screen in existence, small-scale and perhaps a tomb model, was excavated from

the tomb at Ma-wang-tui that housed figs. 10 and 35. It is painted in a style close to theirs, with a back-turning dragon soaring among clouds; see *Ch'ang-sha Ma-wang-tui i-hao Han mu*, vol. 2, pl. 192. For more on screens, see Michael Sullivan, "Notes on Early Chinese Screen Painting," *Artibus Asiae*, 27 (1965): 239-54; for extensive notes on screens and other formats, see van Gulik, *Chinese Pictorial Art*.

11. The example illustrated here is part of a seventy-seven slip, hemp-bound military inventory, excavated in 1930 at Chü-yen, Kansu Province, and has been called the oldest complete Chinese book still in existence.

12. Chang Yen-yüan, writing in the ninth century, mentioned a fan painting by the calligrapher Wang Hsi-chih of the fourth century (cf. fig. 7). He also told the story of Wang's famous son, Hsien-chih, who was painting a fan when he dropped his brush; like Ts'ao Pu-hsing (p. 7, above), he made the best of it, turning the accidental streaks into a black brindled cow "which was very much the last word in subtlety." See Chang Yen-yüan, *Li-tai ming-hua chi* (*A Record of the Famous Painters of All Dynasties*, A.D. 847), trans. William Acker, *Some T'ang and Pre-T'ang Texts on Chinese Painting* (2 vols.; Leyden: E. J. Brill, 1954, 1974), 1:40-41.

The Elements of Painting

1. *Chou Li Cheng Chu* (*Ssu-pu pei-yao* ed.) (Shanghai: Chung-hua shu-chü, 1936?, vol. 4, chap. 40 ("K'ao-kung chi" section), pp. 17a-18a.

2. Trans. Richard Barnhart, "Wei Fu-jen's *Pi Chen T'u* and the Early Texts on Calligraphy," *Archives of the Chinese Art Society of America*, 18 (1964): 16.

3. This work is regarded as a Ch'ing period rubbing of a late tenth century engraving, which in turn was based on a T'ang copy of either the original or of an intermediary copy; see Tseng Yu-ho Ecke, *Chinese Calligraphy* (Philadelphia: Philadelphia Museum of Art, 1971), cat. no. 8.

4. A fifth major calligraphic type, the semi-cursive form known as "running script," *hsing-shu*, has been eliminated here for simplicity's sake.

5. This example is regarded as a thirteenth century rubbing taken from a thirteenth century engraving which was modeled on a seventh century cutting that was derived from a seventh century brush copy of the original; see Ecke, *Chinese Calligraphy*, cat. no. 9. To the modern critic, the T'ang influence is readily apparent, as it is in fig. 5, but for many centuries this served as an authentic reflection of Wang's style. The original styles of Wang Hsi-chih and Chung Yu are now in part obscured and a matter of scholarly argument. Two other early versions of this work exist, one reproduced in *Shodo Zenshu* (Tokyo: Heibonsha, 1961), vol. 4, pl. 46, closer to the original but lacking the complementary regular script forms (fig. 7h) which serve our purpose here.

6. For more information on these six examples, see Ecke, *Chinese Calligraphy*, cat. nos. 4, 7, 8, 9, 27, 37; for Yen Chen-ch'ing, see cat. no. 16.

7. Their story is told in greater detail in Han Chuang (John Hay), "Hsiao I Gets the Lan-t'ing Manuscript by a Confidence Trick," *National Palace Museum Bulletin*, vol. 5, no. 3 (July-August 1970), no. 6 (January-February 1971).

8. More detailed comments on Hui-neng as he appears here and in a companion piece, soon to be discussed (fig. 24), may be found in Jan Fontein and Money Hickman, *Zen Painting and Calligraphy* (Boston: Museum of Fine Arts, 1970), pp. 15-19.

9. The best modern source, in Chinese only, is Yü Fei-an, *Chung-kuo hua yen-se ti yen-chiu* (*Studies on Color in Chinese Painting*) (Peking: Chao-hua mei-shu, 1955).

10. Cf. Legge, trans., *The Confucian Analects*, pp. 230-31.

11. Cf. Ch'u Ta-kao, trans., *Tao Te Ching* (London: George Allen and Unwin, 1937), p. 24.

12. Kuo Hsi, *An Essay on Landscape Painting* (ca. 1070), trans. Shio Sakanishi (London: John Murray, 1936), pp. 61-62.

13. Some of the works printed here in black and white are available elsewhere in color: fig. 36

and full color details of fig. 10 are in *Ch'ang-sha Ma-wang-tui i-hao Han mu*, vol. 2, pls. 157, 72-77; all or part of figs. 15, 20, 21, 26, 27 are in James Cahill, *Chinese Painting* (Geneva: Skira, 1960), pp. 22, 49, 36, 85, 87; fig. 16 is in Terukazu Akiyama and Saburo Matsubara, *Arts of China, III: Buddhist Cave Temples, New Researches* (Tokyo and Palo Alto: Kodansha, 1969), pl. 56.

14. Cf. Aschwin Lippe, "Kung Hsien and the Nanking School—II," *Oriental Art*, n.s. 4 (Winter 1958): 159-60.

15. Chu Ching-hsüan, *T'ang-ch'ao ming-hua lu* (*Celebrated Painters of the T'ang Period*, ca. A.D. 840), in Shimada, "Concerning the *I-p'in* Style of Painting—I," trans. James Cahill, *Oriental Art*, n.s. 7 (Summer 1961): 68.

Composition: The Art of Illusion

1. Tsung Ping, *Hua shan-shui hsü* (*A Preface on Landscape Painting*, before A.D. 443), trans. Michael Sullivan, *The Birth of Landscape Painting in China* (Berkeley: University of California Press, 1962), pp. 102-3.

2. Hsieh Ho, *Ku hua-p'in lu* (*Old Record of the Classification of Painters*, ca. A.D. 475), trans. A. C. Soper, "The First Two Laws of Hsieh Ho," *Far Eastern Quarterly*, 8, no. 4 (1949): 423.

3. Ch'ao Pu-chih, *Ching-yü-sheng chi* (ca. 1090), in Yü Chien-hua, ed., *Chung-kuo hua-lun lei-pien* (Peking: Chung-kuo ku-tien i-shu, 1957), p. 66.

4. Excavated in 1972 from the same tomb that preserved the important lacquer paintings mentioned in chapter 1, ns. 7 and 10, above; see Fong Chow, "Ma-wang-tui: A Treasure-Trove from the Western Han Dynasty," *Artibus Asiae*, 35 (1973): 5-14; cf. chap. 2, note 13, above.

5. For more on texture strokes, see Benjamin March, *Some Technical Terms of Chinese Painting* (Baltimore: Waverly Press, 1935), pp. 33-38; James Cahill, "Some Rocks in Early Chinese Painting," *Archives of the Chinese Art Society of America*, 16 (1962): 77-87; Li Lin-ts'an, "Texture Strokes in Chinese Landscape Painting," *National Palace Museum Bulletin*, 8 (May-June 1973):1-13.

6. I doubt that this work represents the tragic flight of Emperor Ming-huang from his capital; two other versions of this composition, one in the University Museum, Philadelphia, one in the National Palace Museum, Taipei, are illustrated and discussed in Max Loehr, *The Great Painters of China* (Oxford: Phaidon Press, 1980), pp. 68-73.

7. Perhaps the first to put this outlook into print was the scholar Shen Kua of the eleventh century, who, although a noted scientist, criticized the tenth century master, Li Ch'eng, for trying to control his audience's point of view by means of fixed architectural perspectives and thus failing to "take the larger view of smaller things"; Yü Chien-hua, *Chung-kuo hua-lun lei-pien*, p. 625.

8. Kuo Hsi, *An Essay on Landscape Painting*, p. 41.

9. Trans. Richard Edwards, *The Field of Stones: A Study of the Art of Shen Chou* (Washington, D.C.: Freer Gallery of Art, 1962), p. 41.

Composition: The Art of Abstraction

1. Cf. Acker, *Some T'ang and Pre-T'ang Texts*, 1:61-63, 81ff.

2. I have again omitted the semi-cursive "running" script, in which strokes are linked but not as radically abbreviated as in the draft script. A "running" version of *shu* might be written 書 or more briefly 书 .

3. See Edwards, *The Field of Stones*, pl. 18a.

4. Cahill, *Chinese Painting*, pp. 180-81.

5. Liu Hsieh, *The Literary Mind and the Carving of Dragons*, trans. Vincent Yu-chung Shih (New York: Columbia University Press, 1959), pp. 8-9.

6. For an early example of this v-shaped convention, see the well-known eighth century silk fragment from Turfan, now in the Fogg Museum, Cambridge, reproduced in Laurence Sickman and A. C. Soper, *The Art and Architecture of China* (Baltimore: Penguin Books, 1971), pl. 115.

7. For further commentary on this painting, see Fontein and Hickman, *Zen Painting and Calligraphy*, pp. 8-12.

8. Chang Yen-yüan, *Li-tai ming-hua chi*; cf. Acker, *Some T'ang and Pre-T'ang Texts*, 1:154-55.

9. For a report on this unusual event, see James Cahill, "The Return of the Absent Servants: Chou Fang's *Double Sixes* Restored," *Archives of the Chinese Art Society of America*, 15 (1961): 26-28.

10. Cf. James Cahill, *Hills Beyond a River: Chinese Painting of the Yüan Dynasty* (New York: Weatherhill, 1976).

11. This version is believed to be derived from a copy by the tenth century master, Kuo Chung-shu, of the original; it is fully illustrated in Berthold Laufer, "The Wang Ch'uan T'u, A Landscape of Wang Wei," *Ostasiatische Zeitschrift*, 1(1912-13): 28-55.

12. For a discussion of Wang Yüan-ch'i's version of this work, its theoretical basis, and its place in history, see Wen Fong's essay in Roderick Whitfield et al., *In Pursuit of Antiquity* (Princeton: The Art Museum, 1969), pp. 180-86; the work is catalogued, with a translation of Wang Wei's twenty poems, on pp. 199-208.

13. See Burton Watson, trans., *Records of the Historian: Chapters from the Shih-chi of Ssu-ma Ch'ien* (before 90 B.C.) (New York: Columbia University Press, 1958), pp. 55-67.

14. Other later copies of this work still exist: one attributed to Chao Meng-fu, of the fourteenth century, is illustrated in Hay, "Hsiao I," pt. 2, pl. 2; another, attributed to his son, Chao Lin, is reproduced in Chu-tsing Li, *A Thousand Peaks and Myriad Ravines: Chinese Paintings in the Charles A. Drenowatz Collection* (Ascona: Artibus Asiae, 1974), vol. 1, cat. no. 1: yet another, in the Metropolitan Museum of Art, bears a spurious Chao Meng-fu signature. One version exists in the Palace Museum, Peking, perhaps from the Southern Sung period, and is published in *K'ao-ku yü wen-wu*, 1980, no. 1, pl. 9; other versions are in the Brooklyn Museum and the Liaoning Provincial Museum.

15. George Rowley, *Principles of Chinese Painting* (2nd ed.; Princeton: Princeton University Press, 1959), p. 36.

16. Wu Chen's *Central Mountain* and Ni Tsan's *Jung-hsi Studio* are catalogued and their inscriptions and seals are translated in Chang Kuang-pin, *The Four Masters of the Yüan* (Taipei: National Palace Museum, 1975), pp. 51-52, 67-68. *P'ing-tan* is most frequently translated as "bland."

Selected Bibliography

Acker, William. *Some T'ang and Pre-T'ang Texts on Chinese Painting*. 2 vols. Leyden: E. J. Brill, 1954, 1974.

Bush, Susan. *The Chinese Literati on Painting, Su Shih (1037-1101) to Tung Ch'i-ch'ang (1555-1636)*. Cambridge: Harvard University Press, 1971.

Cahill, James. *Chinese Painting*. Geneva: Skira, 1960.

Ch'en Chih-mai. *Chinese Calligraphers and Their Art*. London: Cambridge University Press, 1966.

Contag, Victoria, and C. C. Wang. *Seals of Chinese Painters and Collectors of the Ming and Ch'ing Periods* (1940). Rev. ed. Hong Kong: Hong Kong University Press, 1966.

Ecke, Tseng Yu-ho. *Chinese Calligraphy*. Philadelphia: Philadelphia Museum of Art, 1971.

Fong, Wen. "The Problem of Forgeries in Chinese Painting." *Artibus Asiae*, 25 (1962): 95-119.

Fu, Marilyn, and Shen C. Y. Fu. *Studies in Connoisseurship: Chinese Paintings from the Arthur M. Sackler Collection*. Princeton: The Art Museum, 1973.

Fu, Shen C.Y. *Traces of the Brush*. New Haven: Yale University Art Gallery, 1977.

Goepper, Roger. *The Essence of Chinese Painting*. Boston: Boston Book and Art Shop, 1963.

Gulik, Robert Hans van. *Chinese Pictorial Art as Viewed by the Connoisseur*. Rome: Instituto Italiano per il Medio ed Estremo Oriente, 1958.

Kuo Hsi. *An Essay on Landscape Painting* (ca. 1070). Translated by Shio Sakanishi. London: John Murray, 1936.

Ledderose, Lothar. "An Approach to Chinese Calligraphy." *National Palace Museum Bulletin*, vol. 7, no. 1 (March-April 1972).

_____. *Mi Fu and the Classical Tradition of Chinese Calligraphy*. Princeton: Princeton University Press, 1979.

Lee, Sherman, and Wen Fong. *Streams and Mountains Without End: A Northern Sung Handscroll and Its Significance in the History of Early Chinese Painting*. Ascona: Artibus Asiae, 1955.

March, Benjamin. "Linear Perspective in Chinese Painting." *Eastern Art*, 3 (1931): 113-39.

_____. *Some Technical Terms of Chinese Painting*. Baltimore: Waverly Press, 1935.

Rowley, George. *Principles of Chinese Painting*. 2nd ed. Princeton: Princeton University Press, 1959.

Siren, Osvald. *Chinese Painting, Leading Masters and Principles*. 7 vols. London: Lund, Humphries, 1958.

Sullivan, Michael. "Notes on Early Chinese Screen Painting." *Artibus Asiae*, 27 (1965): 239-54.

_____. *The Three Perfections: Chinese Painting, Poetry, and Calligraphy*. London: Thames and Hudson, 1974.

Tsien Tsueh-hsuin. *Written on Bamboo and Silk: The Beginnings of Chinese Books and Inscriptions*. Chicago: University of Chicago Press, 1962.

Van Briessen, Fritz. *The Way of the Brush: Painting Techniques of China and Japan*. 7th ed. Rutland, Vermont: Charles Tuttle Co., 1974.

Vanderstappen, Harrie. *The T. L. Yüan Bibliography of Western Writings on Chinese Art and Archaeology*. London: Mansell, 1975.

Index

In the text, Chinese names and terms are spelled according to the Wade-Giles System. In the Index, the Pinyin spelling of personal names is supplied in parentheses whenever the two spellings are different.

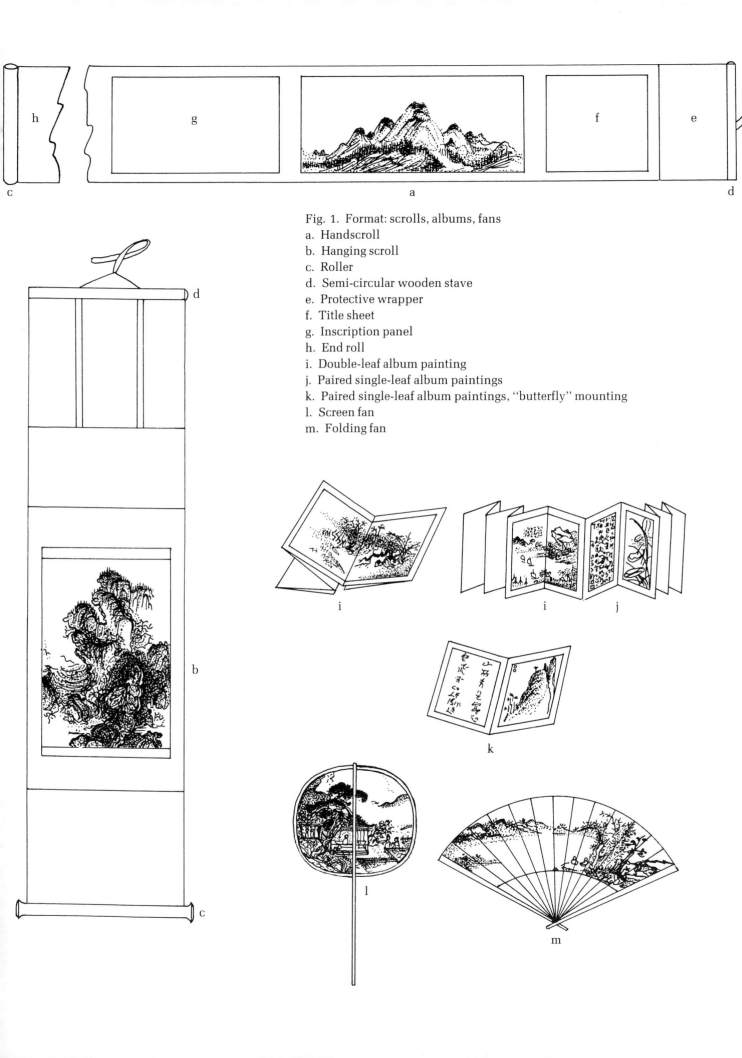

Fig. 1. Format: scrolls, albums, fans
a. Handscroll
b. Hanging scroll
c. Roller
d. Semi-circular wooden stave
e. Protective wrapper
f. Title sheet
g. Inscription panel
h. End roll
i. Double-leaf album painting
j. Paired single-leaf album paintings
k. Paired single-leaf album paintings, "butterfly" mounting
l. Screen fan
m. Folding fan

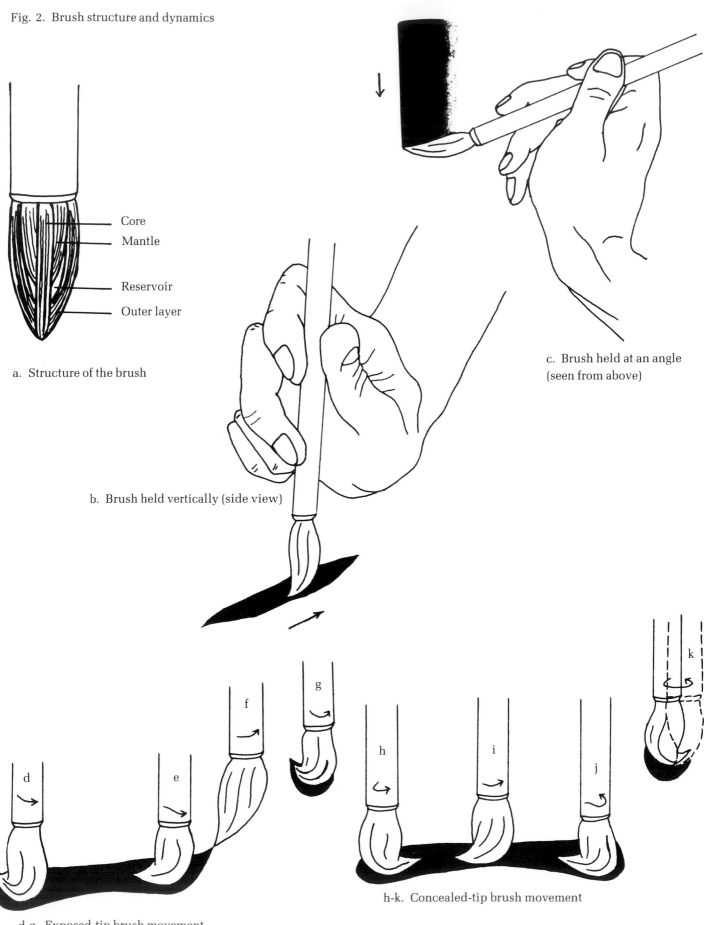

Fig. 2. Brush structure and dynamics

Core
Mantle

Reservoir
Outer layer

a. Structure of the brush

b. Brush held vertically (side view)

c. Brush held at an angle (seen from above)

d-g. Exposed-tip brush movement

h-k. Concealed-tip brush movement

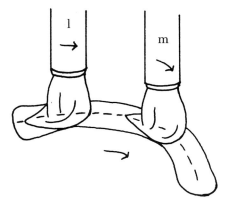

l-m. Path of centered brush tip

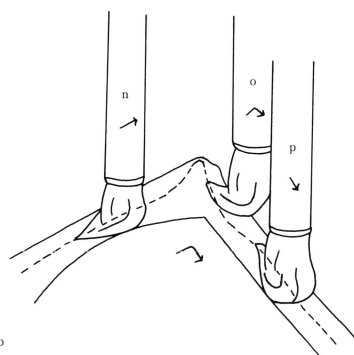

n-s. Path of exposed brush tip

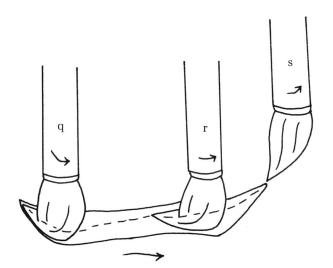

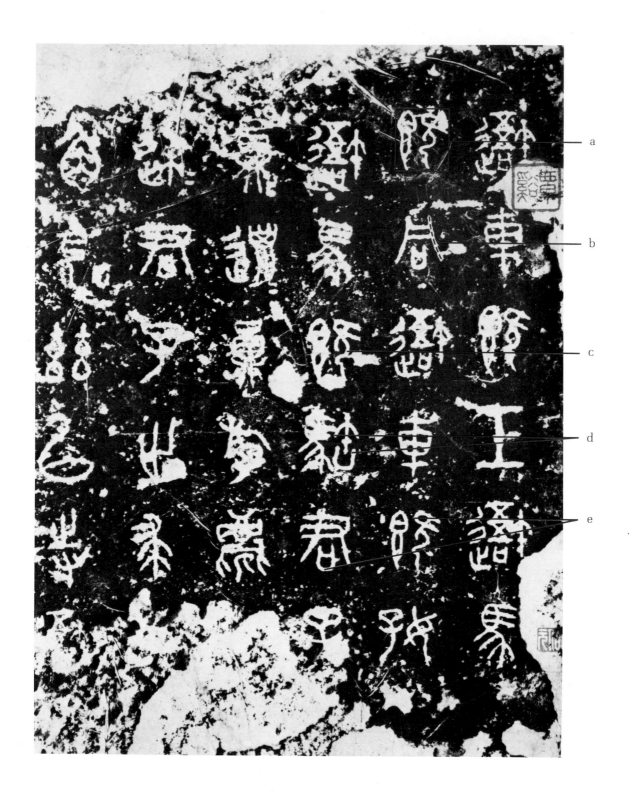

Fig. 3. Anonymous. *Wo ch'e shih Drum*, detail from *The Ten Stone Drums*, Seal script. Engraving from 768(?) B.C., Ming Dynasty rubbing. Handscroll. 45.1 cm. ht. Collection of Wan-go H. C. Weng, Lyme, New Hampshire.

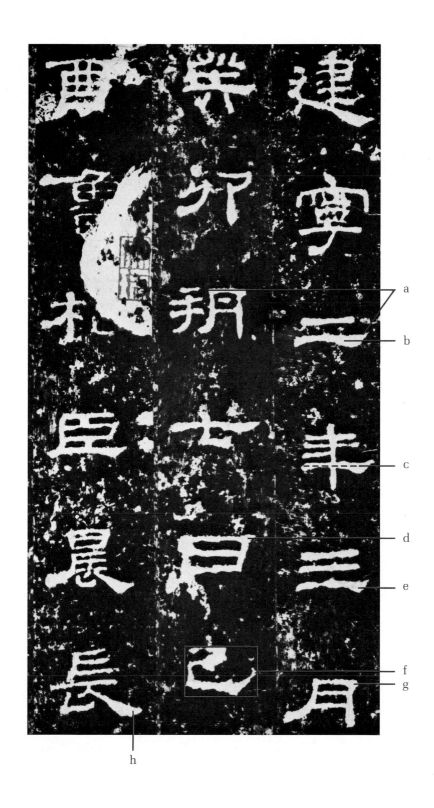

Fig. 4. Anonymous. *Stele of Shih Ch'en*, detail. Clerical script. Engraving from A.D. 169, seventeenth century rubbing. Album leaf. 27.6 cm. × 14.3 cm. Collection of Wan-go H. C. Weng, Lyme, New Hampshire.

Fig. 5. After Chung Yu (A.D. 151-230). *Reply*. Regular script. Composition from A.D. 221; eighteenth(?) century rubbing of a tenth century engraved copy. 27.9 cm. × 35.2 cm. Field Museum of Natural History, Chicago.

Fig. 6. Yeh-lü Ch'u-ts'ai (1190-1244). *Poem of Farewell to Liu Man*. Regular script. Dated 1240. Handscroll. Ink on paper. 36.5 cm. × 278.8 cm. Collection of John M. Crawford, Jr., New York.

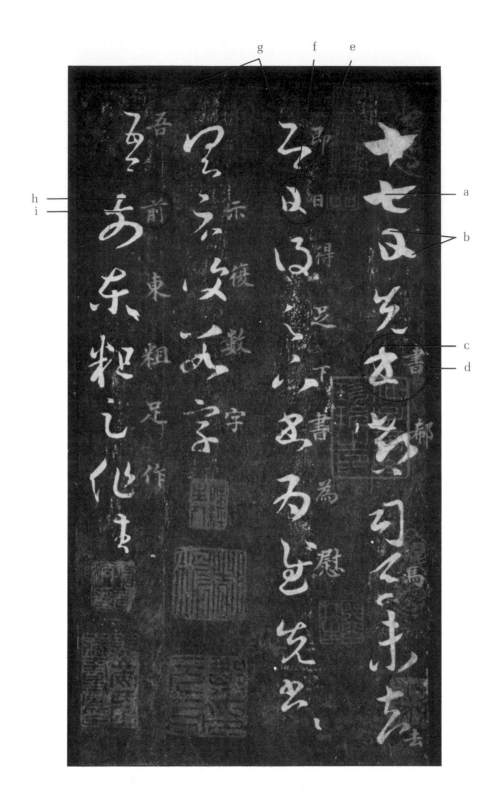

Fig. 7. After Wang Hsi-chih (307?-365?). *On the Seventeenth*. Cursive script. Fourth century composition; thirteenth century rubbing of a thirteenth century engraved copy. Album leaf. 24.1 cm. × 12.7 cm. Collection of Wan-go H. C. Weng, Lyme, New Hampshire.

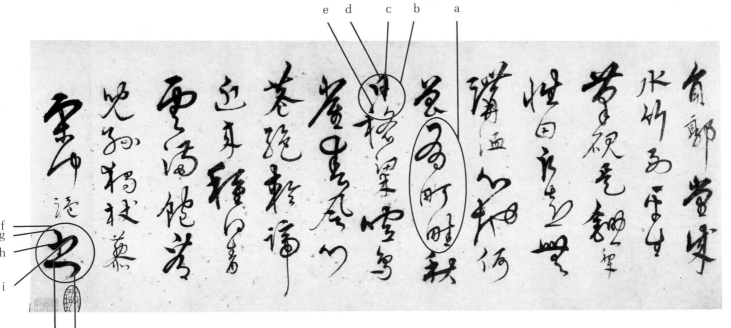

Fig. 8. Sung K'o (1327-87). *Poem.* Cursive script. Handscroll. Ink on paper. 26.7 cm. × 69 cm. Collection of John M. Crawford, Jr., New York.

Fig. 9. Anonymous. Shaman figure from a ceremonial bronze drum. Twelfth century B.C.; modern rubbing. Sen'oku Hakkokan, Sumitomo Collection, Kyoto.

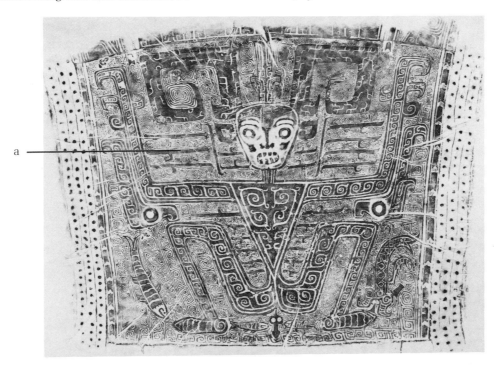

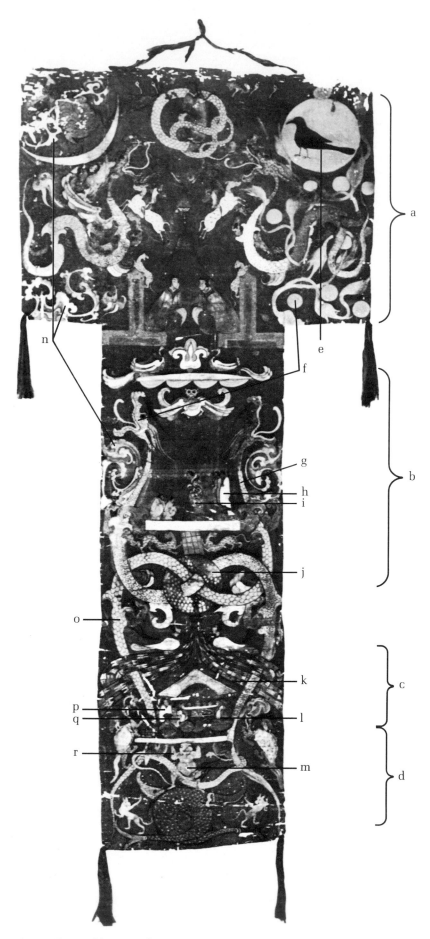

Fig. 10. Anonymous. Funeral banner, from Ma-wang-tui Han tomb number 1, Hunan Province. Ca. 165 B.C. Ink and colors on silk. 205 cm. ht.; 92 cm. wd. above; 47.7 cm. wd. below. Hunan Provincial Museum, Changsha. (See also pl. 1.)

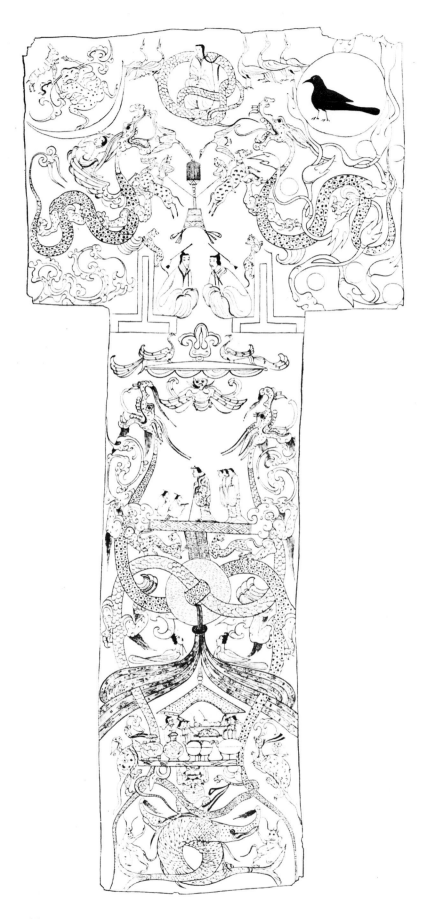

Line drawing of fig. 10

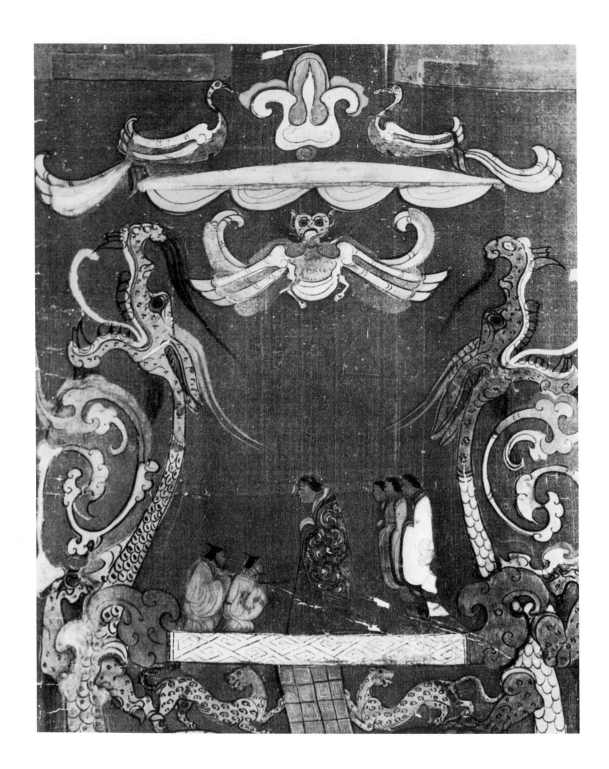

Detail of fig. 10

Fig. 11. Anonymous. *Ching K'o Attempts to Assassinate the King of Ch'in*, from the Wu Family Shrines, Shantung Province. Engraving ca. A.D. 150; modern rubbing. Collection unknown.

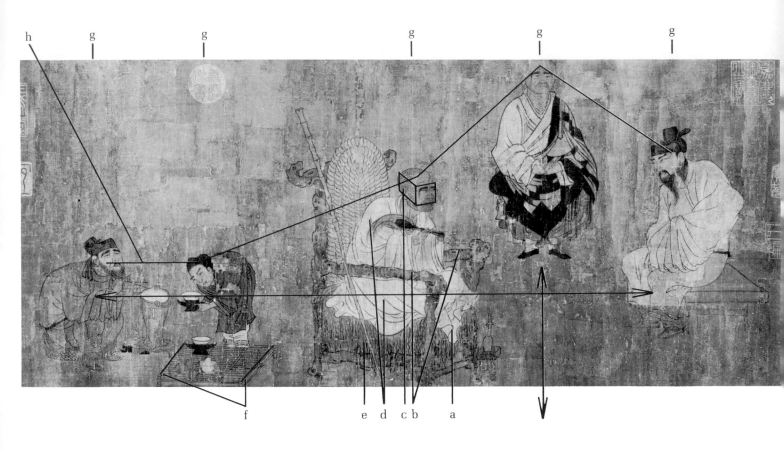

Fig. 12. Yen Li-pen (d. 673), attributed. *Hsiao I Seizes the Orchid Pavilion Manuscript.* Seventh(?) century composition; tenth-eleventh century version. Handscroll. Ink and colors on silk. 27.4 cm. × 64.7 cm. National Palace Museum, Taipei, Taiwan, Republic of China.

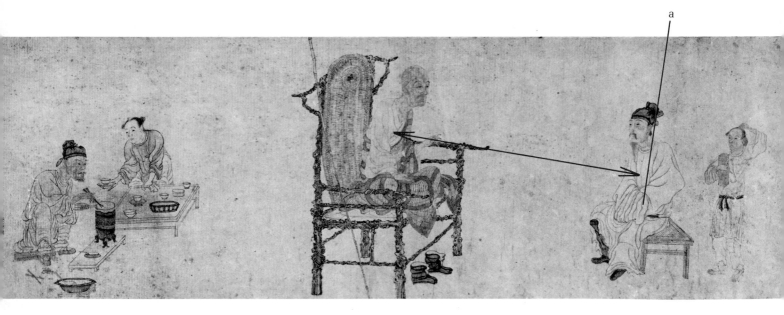

Fig. 13. Anonymous. *Hsiao I Seizes the Orchid Pavilion Manuscript*, after Yen Li-pen(?). Seventh(?) century composition; sixteenth century version. Handscroll. Ink on paper. 24.6 cm. × 77.1 cm. Courtesy of the Smithsonian Institution, Freer Gallery of Art, Washington, D.C.

Fig. 14. Ch'iu Ying (ca. 1510-51). *Hsiao I Seizes the Orchid Pavilion Manuscript*, after Yen Li-pen(?), from *Illustrations of Traditional Texts Written by Six Ming Dynasty Calligraphers*. Seventh(?) century composition; sixteenth century version. Handscroll. Ink on paper. 23 cm. ht. Courtesy of the Smithsonian Institution, Freer Gallery of Art, Washington, D.C.

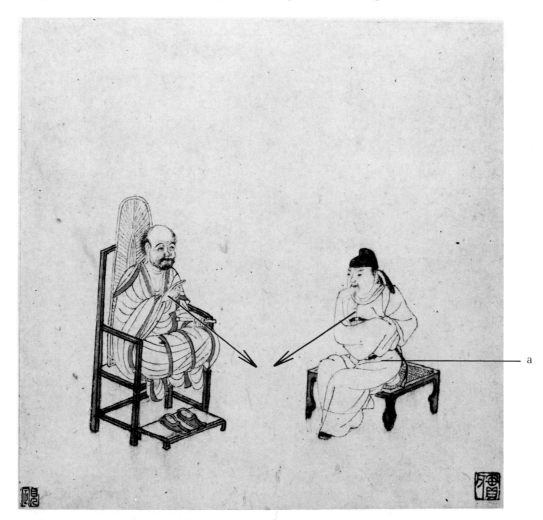

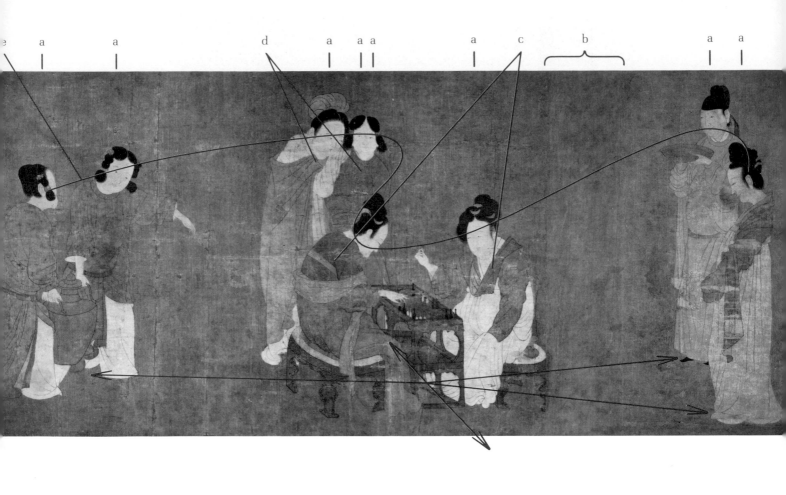

Fig. 15. Chou Fang (act. ca. 780-810), attributed. *Ladies Playing Double-Sixes.* Eighth(?) century composition; tenth-eleventh century version. Handscroll. Ink and colors on silk. 30.7 cm. × 69.4 cm. Courtesy of the Smithsonian Institution, Freer Gallery of Art, Washington, D.C.

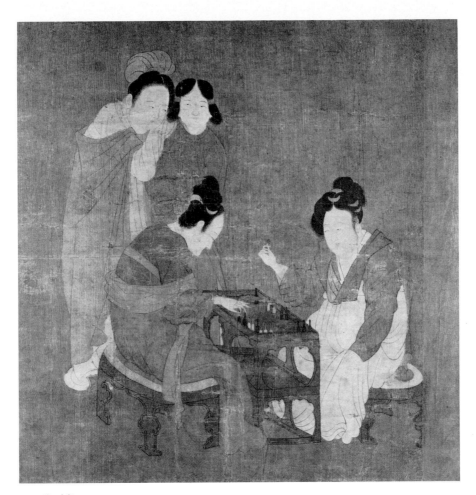

Detail of fig. 15

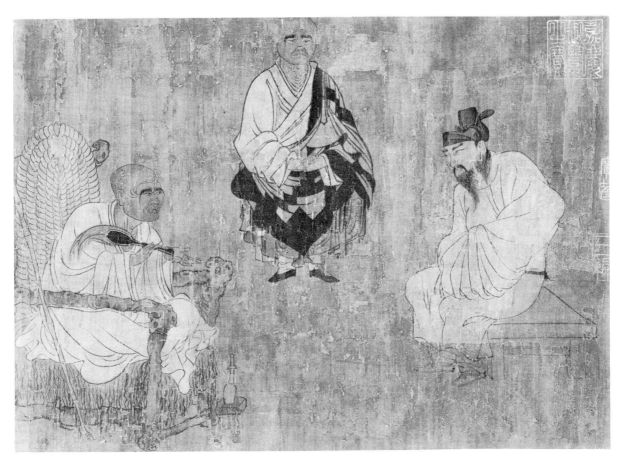

Detail of fig. 12

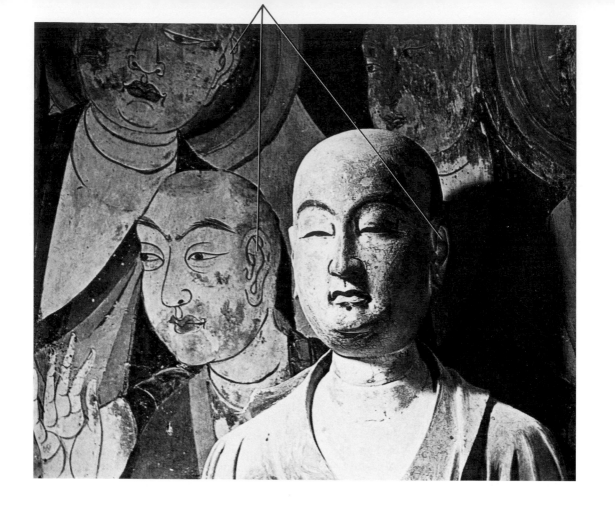

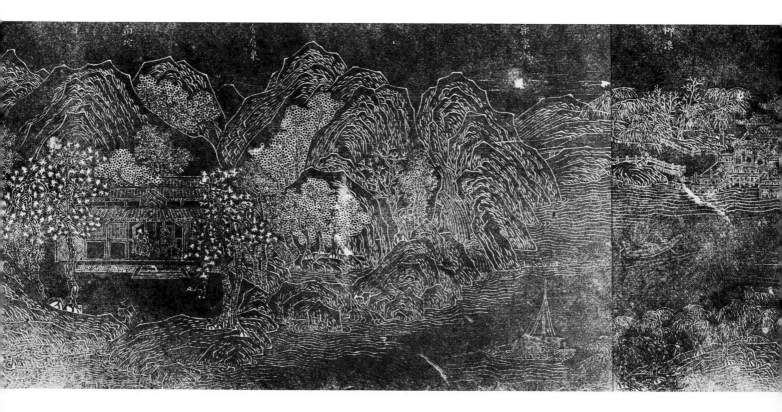

Fig. 16. Anonymous. *Ananda and Disciples*, detail. Eighth century. Clay sculpture and wall painting. Ink and colors. Tun-huang Cave 328, Kansu Province.

Fig. 17. After Wang Wei (699-759). *The Wang River Villa*, section. Eighth century composition; rubbing of an engraved copy dated 1617. Handscroll. The Art Museum, Princeton.

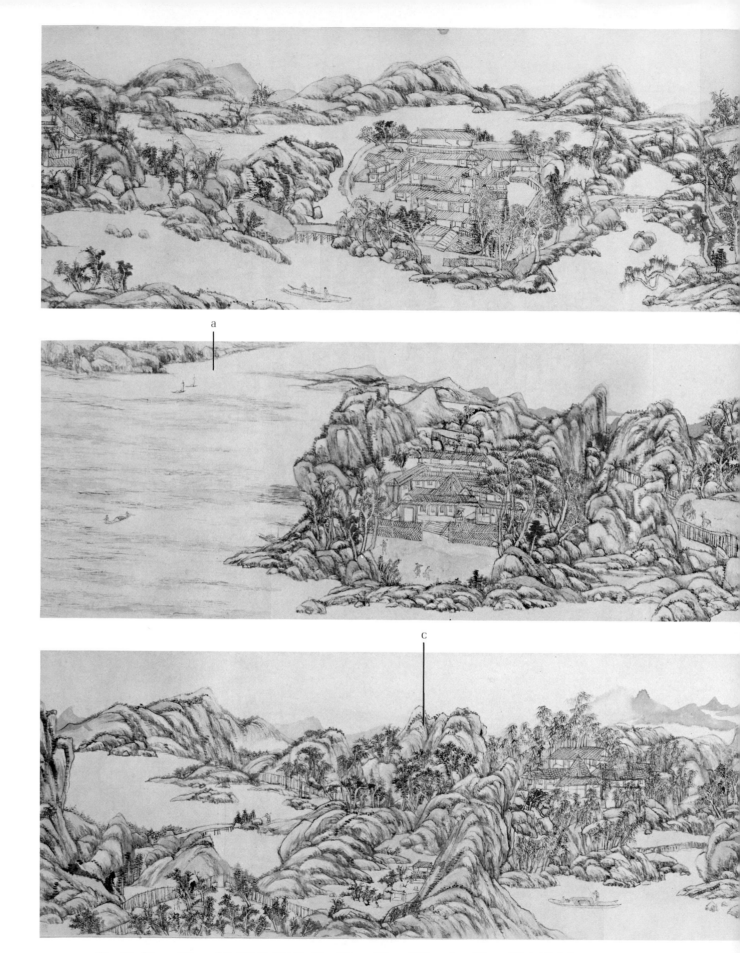

Fig. 18. Wang Yüan-ch'i (1642-1715). *The Wang River Villa*, after Wang Wei. Eighth century composition; 1711 version. Handscroll. Ink and colors on paper. 35.7 cm × 541 cm. Metropolitan Museum of Art, Douglas Dillon Gift. (See also pl. 3.)

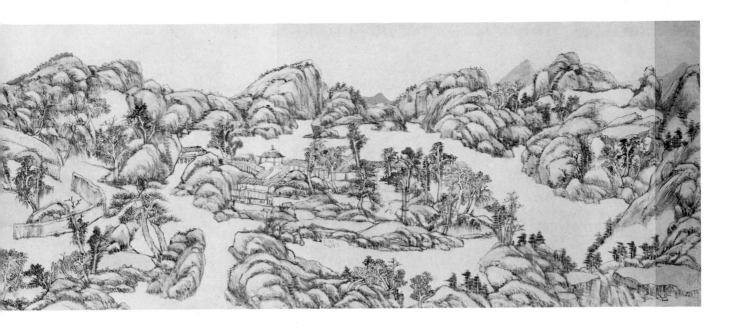

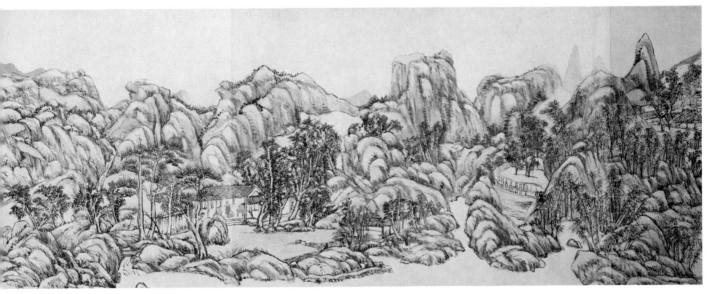

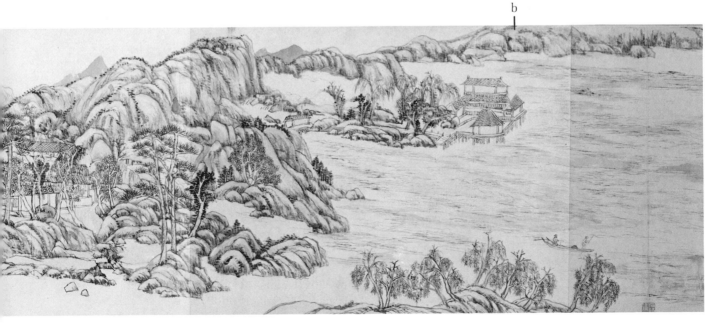

b

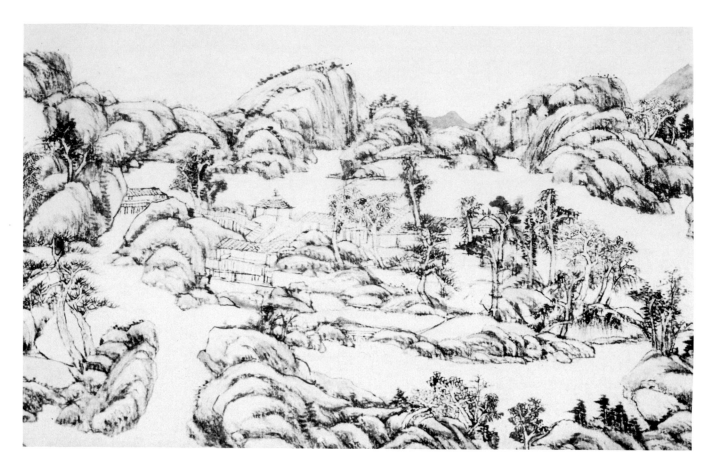

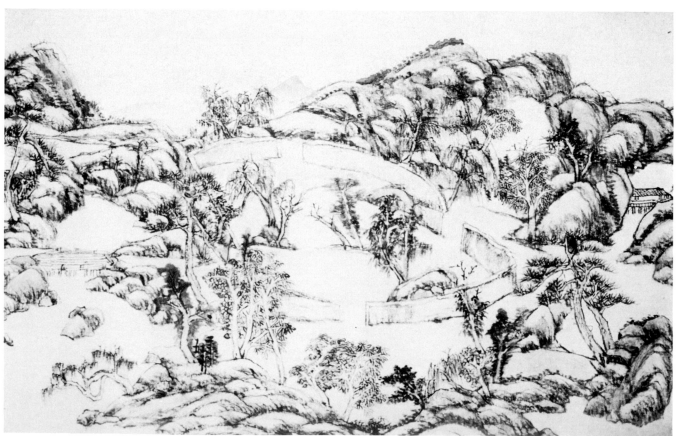

Details of fig. 18

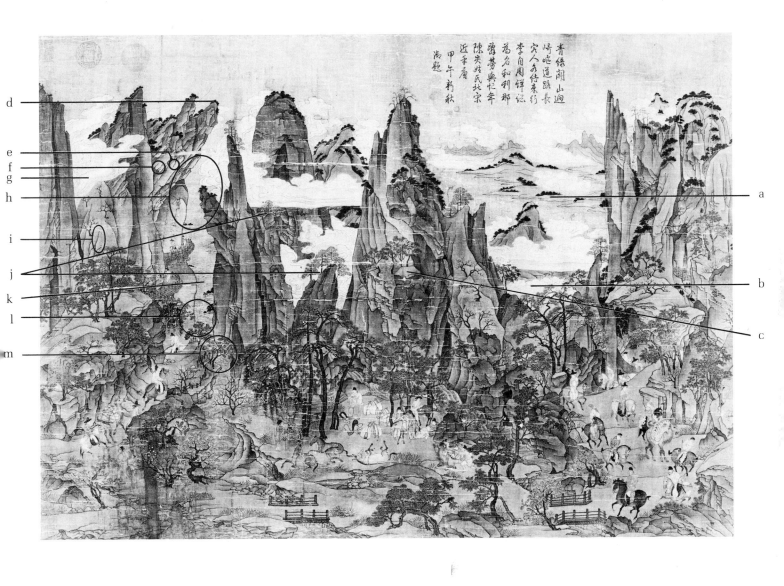

d

e

f

g

h

i

j

k

l

m

a

b

c

青綠開山迥
帰嵯道路長
客人乘傑來行
李自閑洋綠
舊名和利郍
廢券與恬年
陳失姓氏北宋
近承庸
甲午新秋
尚題

Fig. 19. Li Chao-tao (act. ca. 700-30), attributed. *Ming-huang's Journey to Shu*. Eighth-ninth century composition; date of this version uncertain. Hanging scroll. Ink and colors on silk. 55.9 cm. × 81 cm. National Palace Museum, Taipei, Taiwan, Republic of China. (See also pl. 2.)

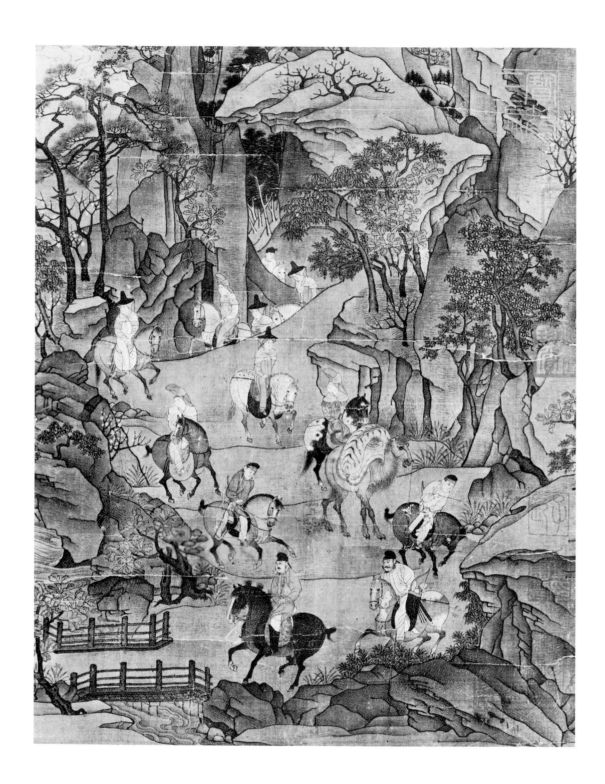

Detail of fig. 19

e　　d　　　　　c　b　　a

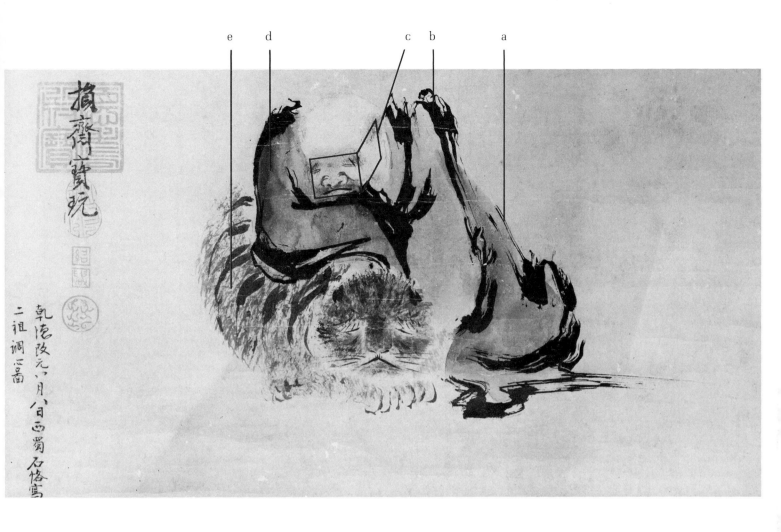

Fig. 20. Shih K'o (early tenth century), attributed. *Buddhist Patriarch and Tiger*. Tenth(?) century composition; thirteenth-fourteenth century version. Handscroll, section, mounted as a hanging scroll. Ink on paper. 25.3 cm. × 64.3 cm. Tokyo National Museum.

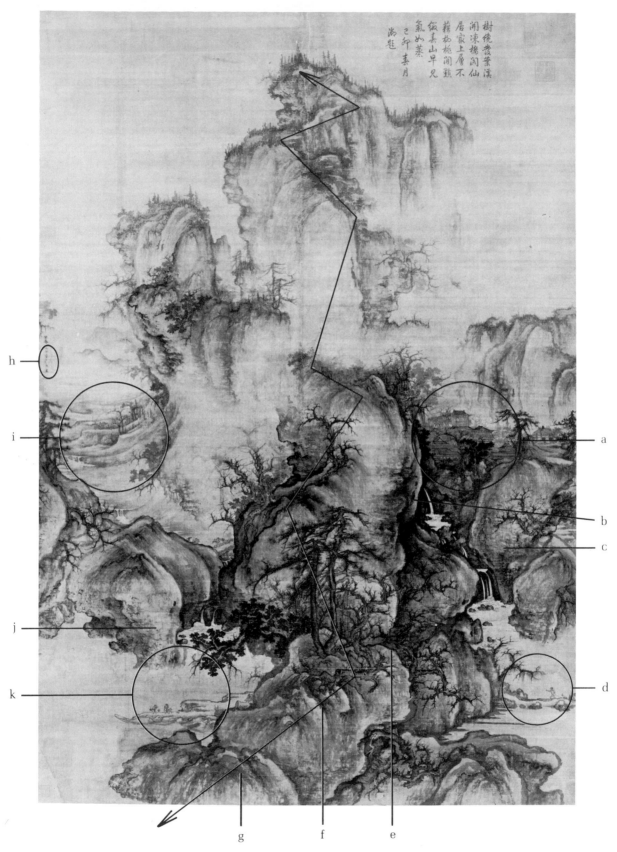

Fig. 21. Kuo Hsi (act. ca. 1060-75). *Early Spring*. Dated 1072. Hanging scroll. Ink and slight color on silk. 158.3 cm. × 108.1 cm. National Palace Museum, Taipei, Taiwan, Republic of China.

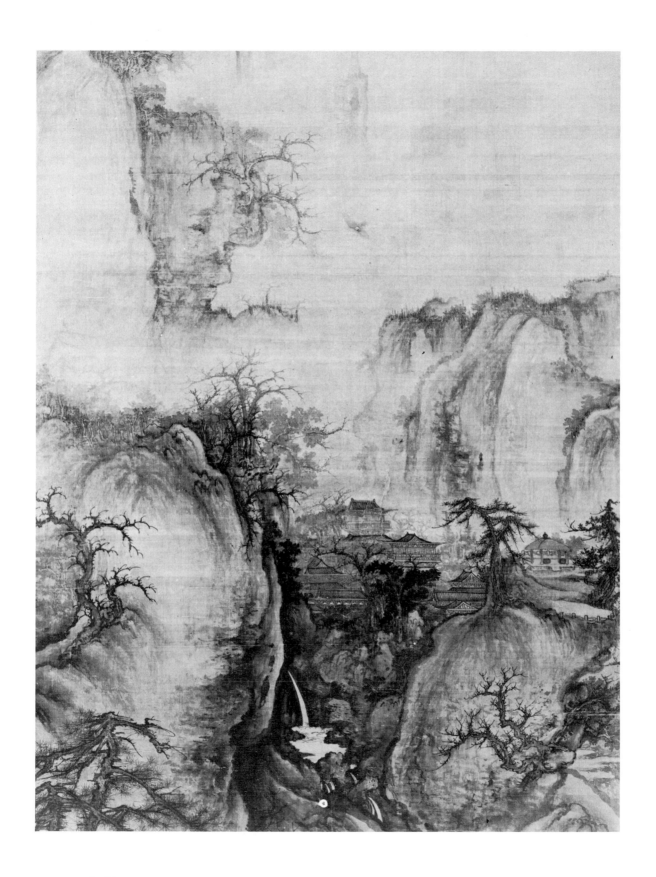

Detail of fig. 21

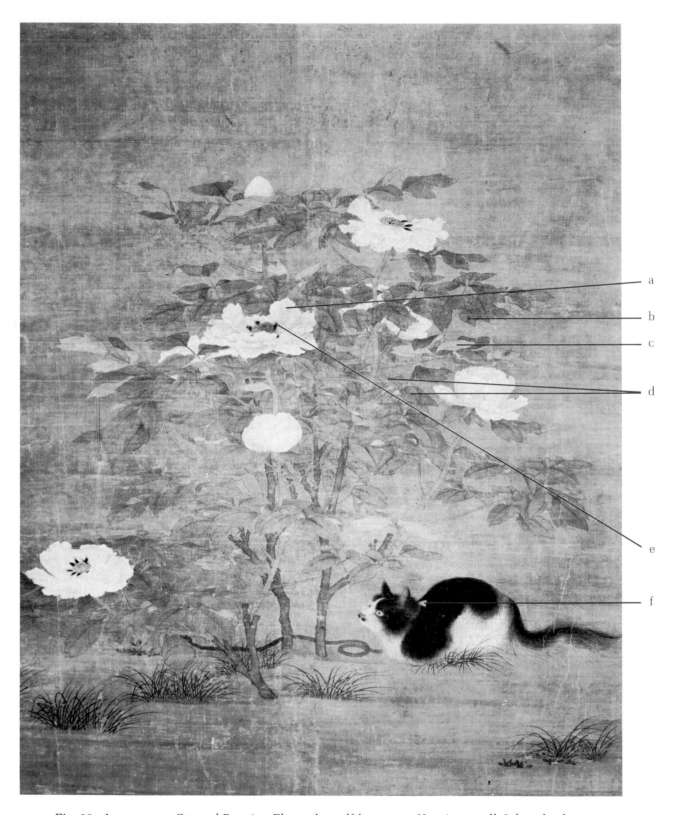

a

b

c

d

e

f

Fig. 22. Anonymous. *Cat and Peonies*. Eleventh-twelfth century. Hanging scroll. Ink and colors on silk. 141 cm. × 107.5 cm. National Palace Museum, Taipei, Taiwan, Republic of China. (See also pl. 4.)

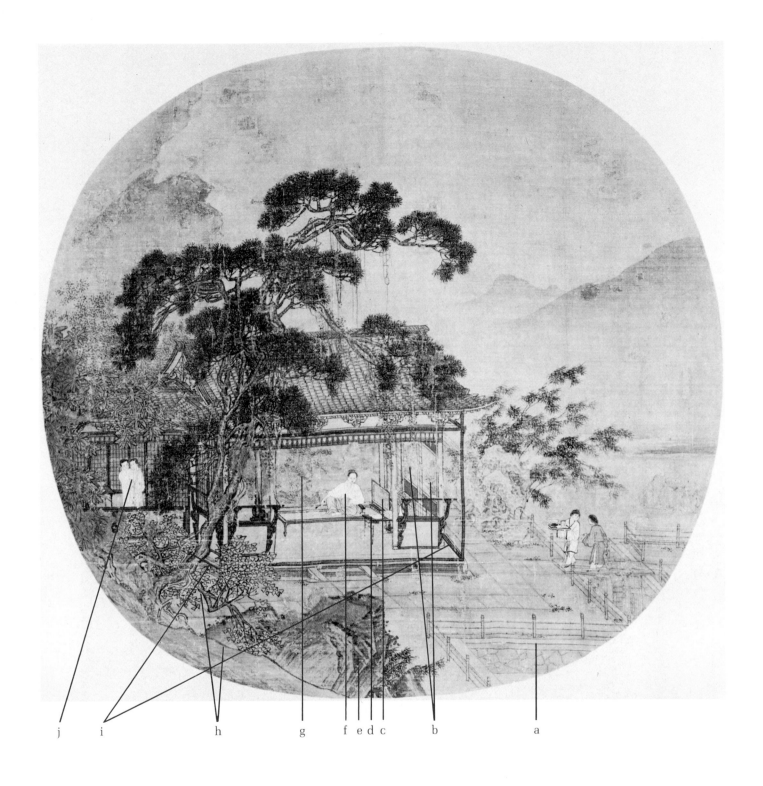

j i h g f e d c b a

Fig. 23. Chao Po-su (1124-84), attributed. *Reading in the Open Pavilion*. Fan painting mounted
as an album leaf. Ink and colors on silk. 24.9 cm. × 26.7 cm. National Palace Museum, Taipei,
Taiwan, Republic of China. (See also pl. 5.)

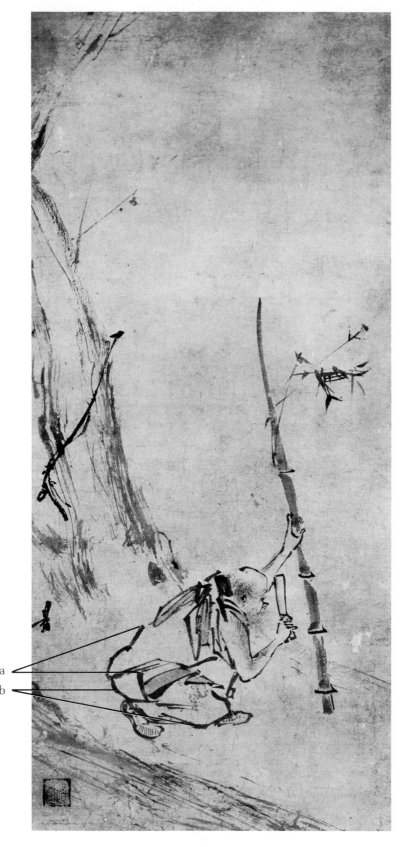

Fig. 24. Liang K'ai (act. ca. 1200). *Hui-neng Chopping Bamboo*. Hanging scroll. Ink on paper. 72.7 cm. × 31.8 cm. Tokyo National Museum.

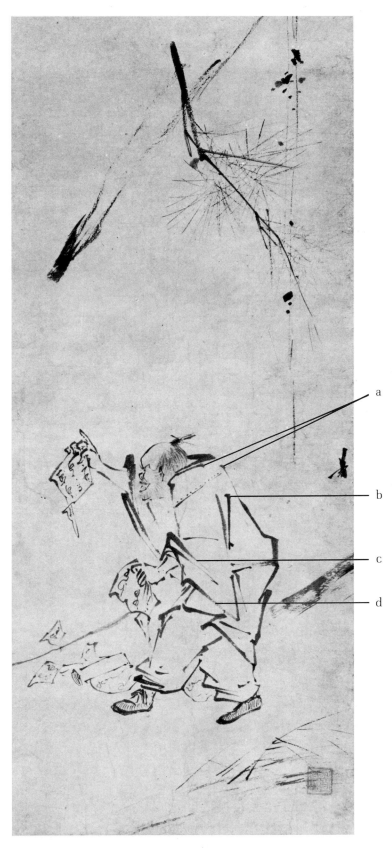

a

b

c

d

Fig. 25. Liang K'ai (act. ca. 1200), attributed. *Hui-neng Tearing Sutras*. Hanging scroll. Ink on paper. 73 cm. × 31.7 cm. Collection of Mitsui Takanaru, Tokyo.

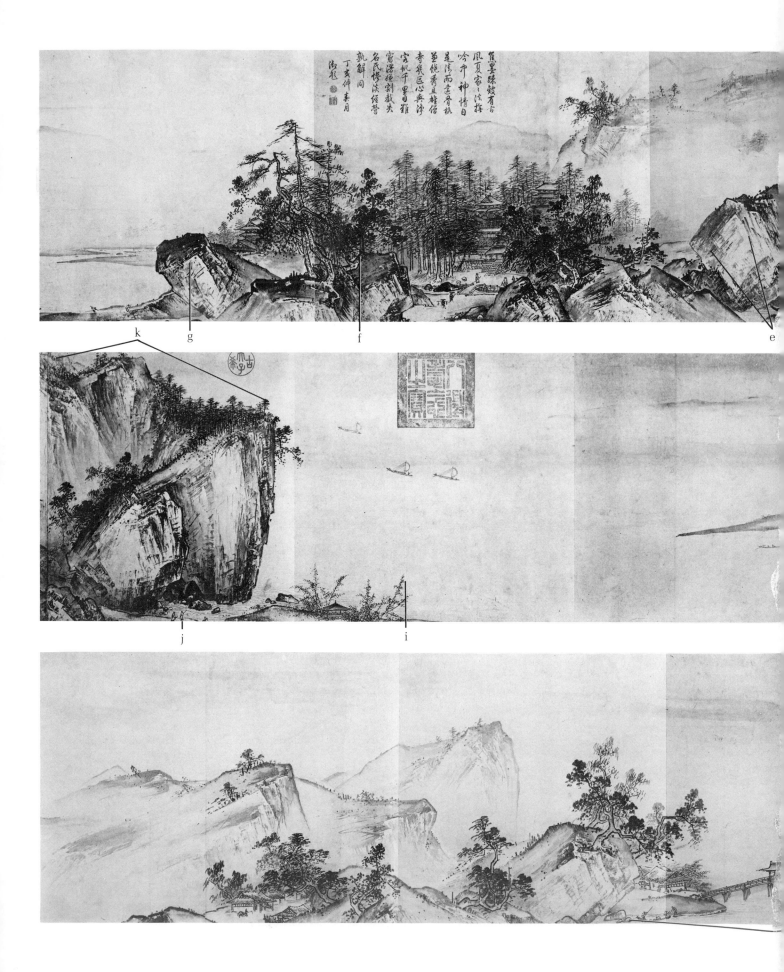

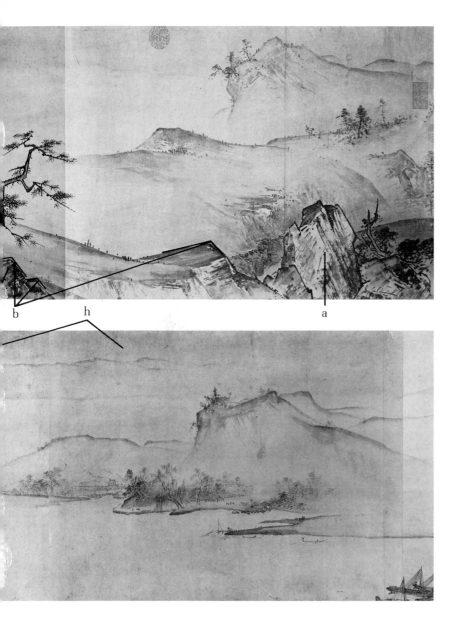

b h a

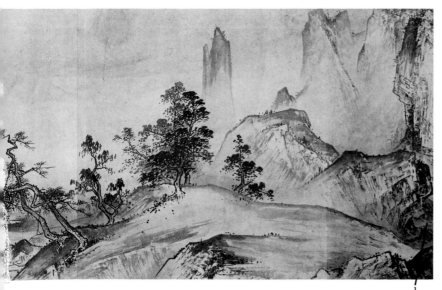

l

Fig. 26. Hsia Kuei (act. ca. 1190-1225). *Pure and Remote Views of Streams and Mountains.* Handscroll, section. Ink on paper. 46.5 cm. × 889.1 cm. National Palace Museum, Taipei, Taiwan, Republic of China.

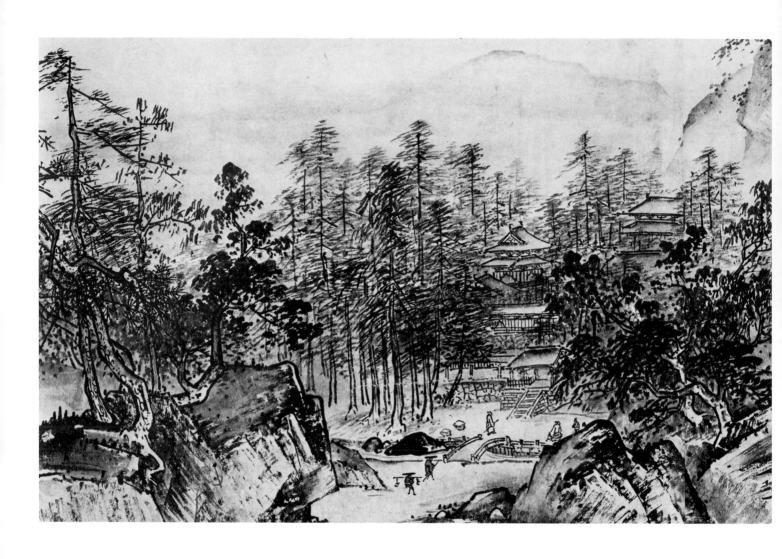

Detail of fig. 26

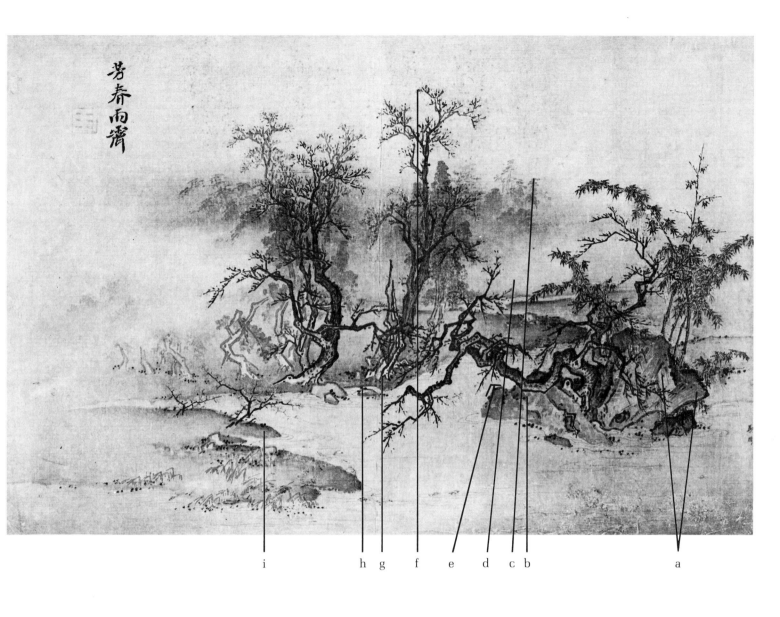

i h g f e d c b a

Fig. 27. Ma Lin (d. after 1246). *Fragrant Springtime, Clearing After Rain*. Album leaf. Ink and slight color on silk. 27.5 cm. × 41.6 cm. National Palace Museum, Taipei, Taiwan, Republic of China.

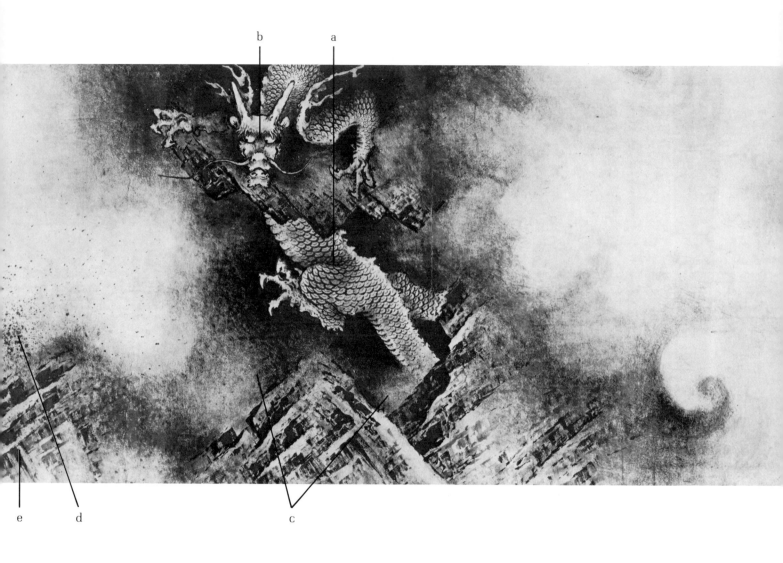

Fig. 28. Ch'en Jung (act. ca. 1235-58). *Nine Dragons Scroll*, section. Handscroll. Ink and slight color on paper. 46.3 cm. × 1096.4 cm. Courtesy of the Museum of Fine Arts, Boston, Francis Gardner Fund.

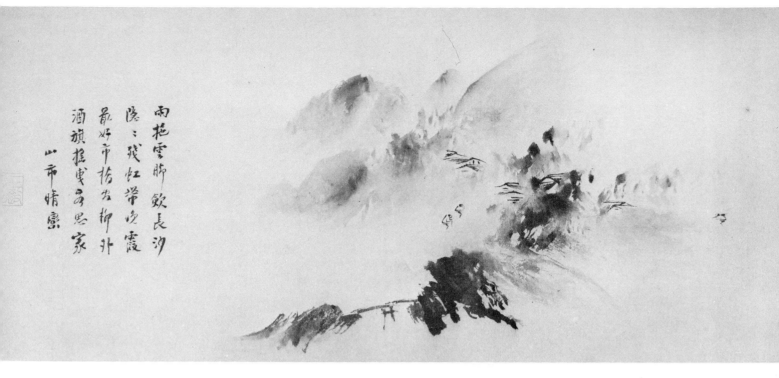

雨拖雲腳歛長沙
隱隱殘虹帶晚霞
最好市橋煙柳外
酒旗搖曳是思家
山市晴嵐

Fig. 29. Yü-chien (mid-thirteenth century). *Mountain Village, Clearing After Rain.* Handscroll, section, mounted as a hanging scroll. Ink on paper. 30.3 cm. × 83.3 cm. Idemitsu Art Museum, Tokyo.

Detail of fig. 29

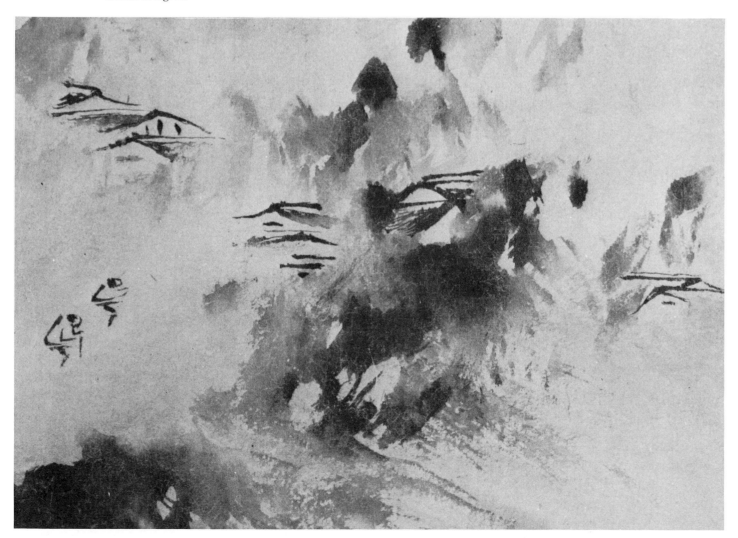

Fig. 30. Wu Chen (1280-1354). *The Central Mountain*. Dated 1336. Handscroll. Ink on paper. 26.4 cm. × 90.7 cm. National Palace Museum, Taipei, Taiwan, Republic of China.

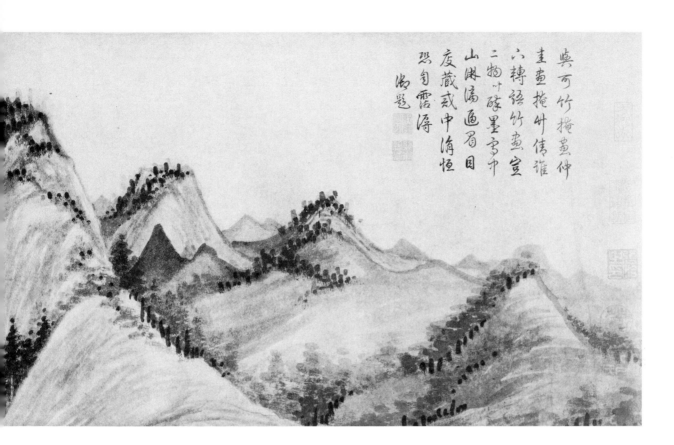

與可竹橙畫仲
圭畫掩竹傳誰
六轉絹竹畫宣
二物葉碟墨穹中
山林滿画眉目
度藏哉中渟恒
恐自雷源
潚題

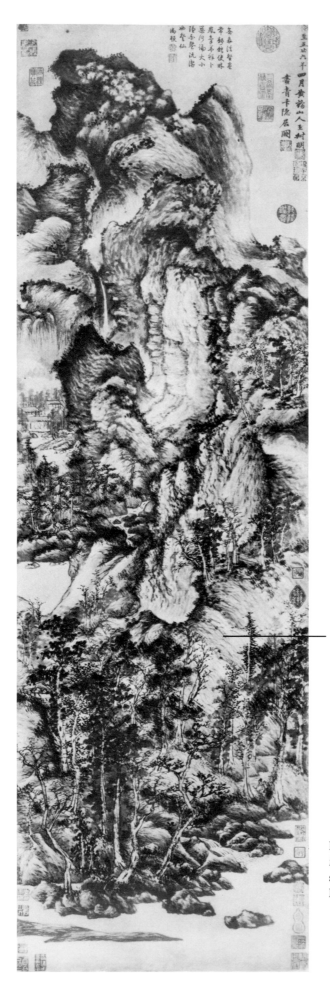

a

Fig. 31. Wang Meng (1305-85). *Secluded Dwelling
in the Ch'ing-pien Mountains.* Dated 1366. Hanging
scroll. Ink on paper. 141 cm. × 42.2 cm. Shanghai
Museum.

Detail of fig. 31

Detail of fig. 31

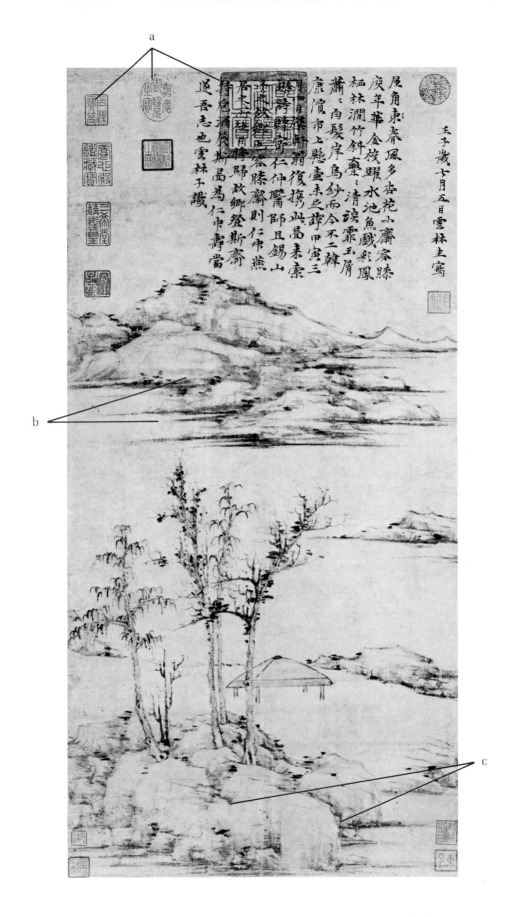

Fig. 32. Ni Tsan (1301-74). Dated 1372. *The Jung-hsi Studio*. Hanging scroll. Ink on paper. 74.4 cm. × 35.5 cm. National Palace Museum, Taipei, Taiwan, Republic of China.

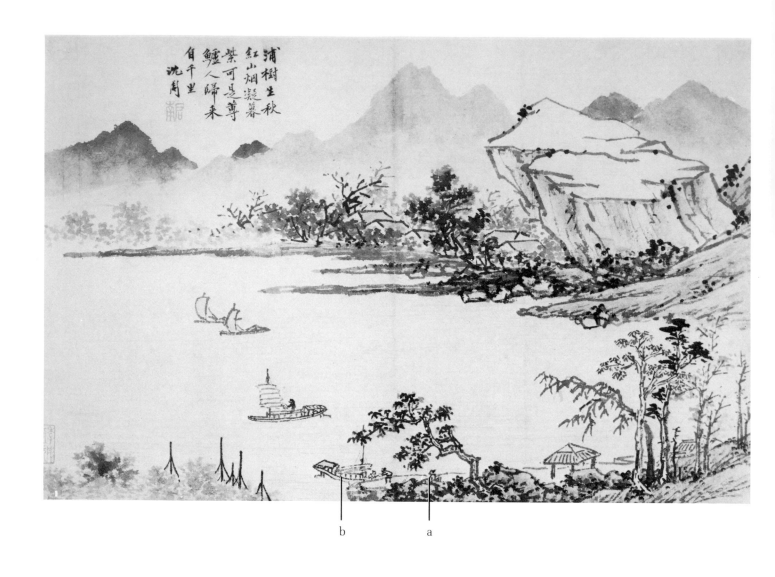

浦樹生秋
紅山烟凝暮
縈可是尊
鱸人歸禾
自千里
沈周

b a

Fig. 33. Shen Chou (1427-1509). *Return from a Thousand Leagues*. Album leaf mounted as a handscroll. Ink on paper. 38.6 cm. × 60.5 cm. Nelson Gallery–Atkins Museum, Kansas City.

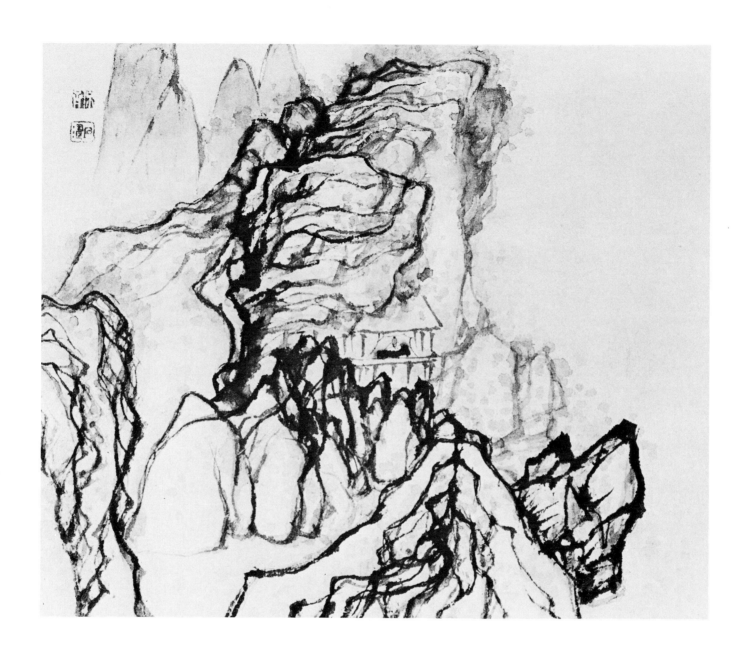

Fig. 34. Tao-chi (1641–before 1720). *Man in a Hut*. Album leaf. Ink and colors on paper. 24.1 cm. × 27.9 cm. Collection of C. C. Wang, New York. (See also pl. 6.)

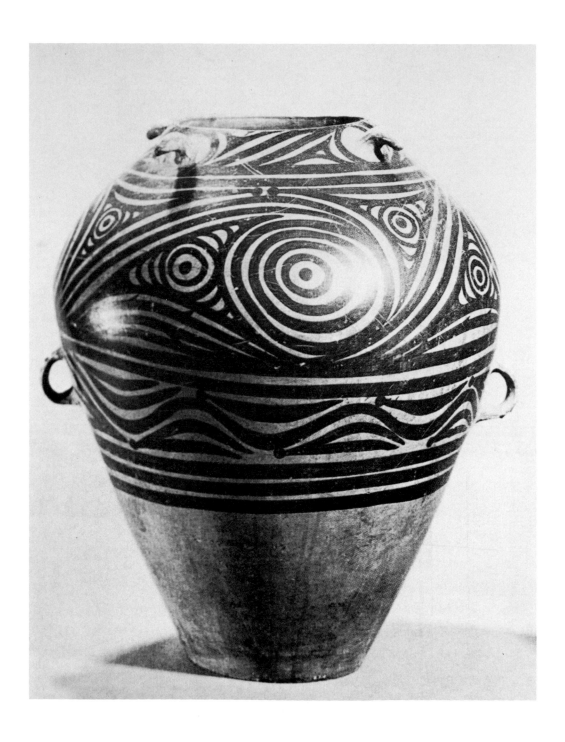

Fig. 35. Ceramic urn, Ma-chia-yao type, from San-p'ing, Yung-ching District, Kansu Province. Ca. 2200 B.C. 48.0 cm. ht. Museum of History, Peking.

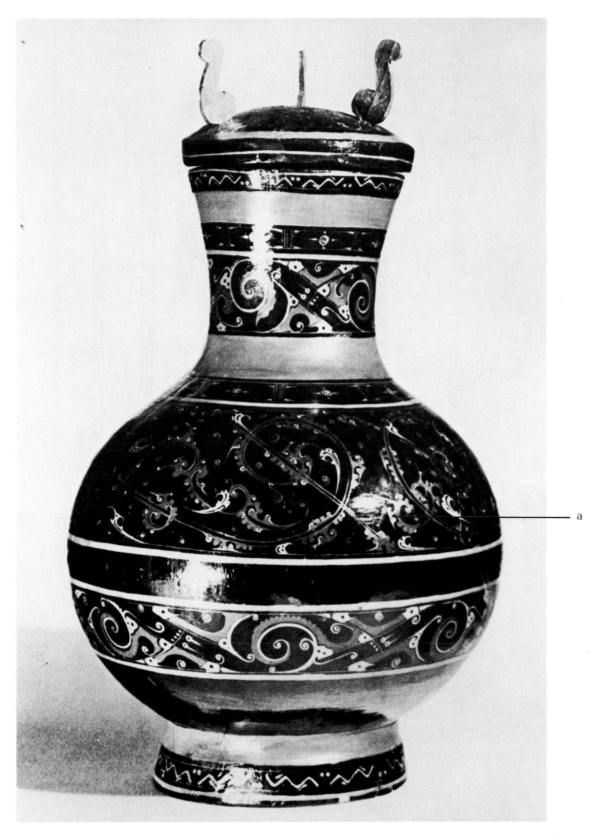

a

Fig. 36. Lacquer Hu-type vessel, from Ma-wang-tui Han tomb number 1, Hunan Province. Ca. 165 B.C. 57 cm. ht. Hunan Provincial Museum, Changsha.

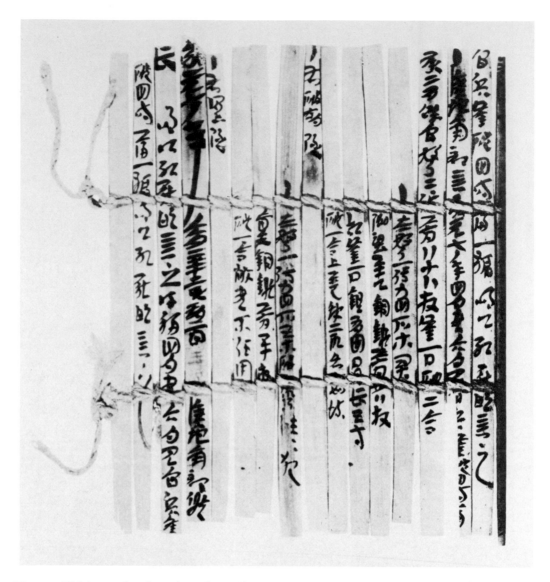

Fig. 37. Writing on bamboo slips, from Chü-yen, Kansu Province. A.D. 93-95. Academia Sinica, Taipei, Taiwan.

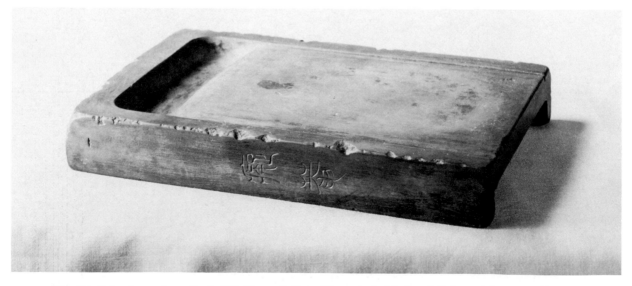

Fig. 38. Ink stone, inscribed "Ch'ih-an." Sung(?) period. National Palace Museum, Taipei, Taiwan, Republic of China.